JAPAN
a pictorial portrait

JAPAN
a pictorial portrait

Foreword by Kenzo Takada

IBC Publishing

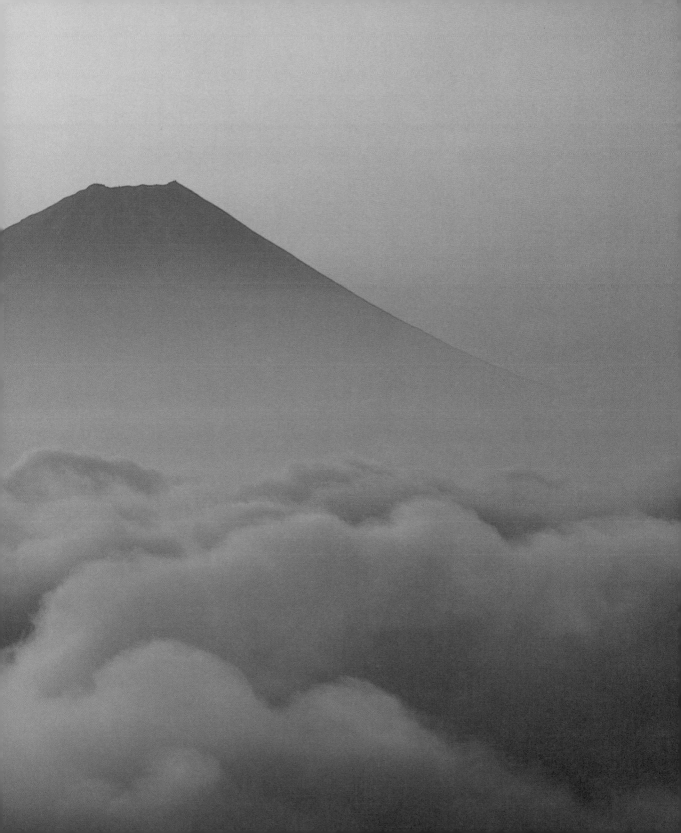

©2005 IBC Publishing, Inc.

All photographs by SEKAI BUNKA PHOTO except:

Page 61 (top): Sado Japanese Crested Ibis Conservation Center
Page 78: Rokuonji
Page 81: Byodoin
Page 128 (bottom): Nihon Sumo Kyokai

Decorative full-page endsheets from *Japanese Patterns*
used courtesy of The Pepin Press.

Published by IBC Publishing, Inc.
Akasaka Community Bldg. 5F, 1-1-8 Moto-Akasaka
Minato-ku, Tokyo 107-0051
www.ibcpub.co.jp

Distributed by Yohan, Inc.
Akasaka Community Bldg. 5/6/7F, 1-1-8 Moto-Akasaka
Minato-ku, Tokyo 107-0051

First Edition 2005
Second Printing January, 2007

ISBN 978-4-925080-93-4
Printed in Japan

Contents

2005 marks the fortieth year since I left for France to try my hand in the fashion world. At the time, I doubt that I really gave much thought to Japan's traditions or the country's culture. Of course, Japanese culture has, like a cut diamond, many wonderful facets. Some of these facets are well known and have been given proper recognition; others perhaps have not yet gained the recognition that they deserve.

Strangely enough, it was only after I had started living in Paris that I came to realize the value of Japan's traditional culture. When I had my first show as a designer and began thinking about who I was and what I was doing, I came to the conclusion that my identity lay in my home country, Japan, and in Asia. What I wanted was for people throughout the world to know more about Japan. Working in Europe, I wanted to express my Japanese sensibility through the medium of fashion design.

Thinking about the Japanese sense of what is beautiful and aesthetically pleasing, the image that came to mind was that of the kimono, the archetype of traditional Japanese dress. Along with being one aspect of Japanese tradition, the kimono is also a living, functioning element in the daily workings of Japanese culture. The simple kimono, according to the season and depending on its use, can take on many forms. And the various articles that go along with wearing a kimono—the *haori*, *hakama*, *obi*, *zori*, *geta*—all have their own value and significance.

Foreword by Kenzo Takada

In Paris, I proposed to design clothing that gave freedom of movement based on the flat-pattern cutting that comes from the kimono, not on the draping and modeling that is fundamental to Western design. In contrast to tight-fitting clothes that cling to the body, I ended up proposing something new, although I admit that whatever success I achieved was in keeping with the tide of the times. Moreover, I also introduced kimono colors and patterns into my work. I believe that my collection, founded on something fundamentally Japanese but altered and provided with new life, possessed a distinctly Asian feeling.

A kimono may be just a kimono, but according to your viewpoint it becomes a source of infinite possibilities. It stimulates the designer's imagination. It makes creation possible through the filter of one's own sense of beauty. I feel more strongly now than ever before that the kimono is Japan's *haute couture* which need not fear comparison with anything else in the world. Japan may be a small country compared to the United States or Europe, but its sense of beauty has something glorious about it, even though it often manifests itself in a very restrained manner.

This sensibility may have developed in response to the country's natural surroundings—the mountains and the seas, the comings and goings of spring, summer, fall, and winter. The four seasons of the year in Japan are distinctly beautiful. It is these seasons that have created the Japanese sensibility, I am sure. By refining the five senses, nature has given us the ability to perceive beauty in our daily lives and in our cultural pursuits. It seems that we have been endowed with an environment that exercises the five senses to the utmost. In turn we have been given the sensitivity to express what we have experienced through the senses.

The seasons also play a part in cuisine. The Japanese meal has been brought to a peak of refinement in *kaiseki ryori*, which makes the best use of the freshest ingredients peculiar to a particular season. But not only that, for in *kaiseki ryori* "to eat" is to enjoy the meal with the eyes as much as with the taste buds. The way the table is set, the tableware, the room in which one eats, all convey a sense of the season. "To eat" does not mean to eat one's fill; rather it means to appreciate a meal with all five senses.

It is the same with the structured spaces that house the body and soul. The traditional wooden home, the landscape garden, the teahouse, the pocket-sized garden (*tsuboniwa*)—all these are filled with possibilities for pleasantly stimulating the senses. There is a feeling of serenity in a simple *chabana* flower arrangement in a *tokonoma* alcove. There is a sense of warm content in the placement of a single flower in an unpretentious vase. This kind of attention to detail provides the means for creating a space that brings true peace of mind. As a result, we are able to escape the madding crowd and enjoy a moment of spiritual relaxation.

I built a teahouse and a Japanese garden in my home in Paris. It seems I was looking for a way to achieve a moment of peace in the Japanese style. From the garden I could sometimes hear a carp jumping in the water or the bamboo trees rustling in the wind. If I could only, even now, become more at one with the inner heart of things. If I could see that beauty which comes to us from the infinite. To live in the heart of Zen, to immerse oneself in the beauty of Japan!

Kenzo Takada

The Four Seasons of Japan

 ## Spring

The seasons of Japan—spring, summer, autumn, and winter—are so different that many Japanese seem convinced that only their country enjoys the beauties and benefits of four separate and distinct seasons. The most dramatic of the four is spring, which bursts into life with the blooming, in turn, of the plum, the peach, and, in late March, the cherry. Most celebrated is the cherry, its pink flowers arraying the trees, its fallen petals carpeting the ground. Under its burdened branches, following tradition, cups of sake are convivially drunk and even a haiku or two is penned.

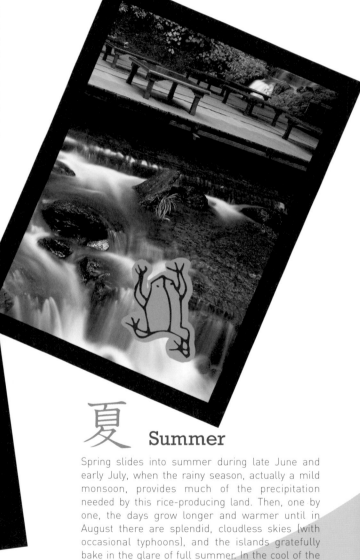

夏 ## Summer

Spring slides into summer during late June and early July, when the rainy season, actually a mild monsoon, provides much of the precipitation needed by this rice-producing land. Then, one by one, the days grow longer and warmer until in August there are splendid, cloudless skies (with occasional typhoons), and the islands gratefully bake in the glare of full summer. In the cool of the evening there are summer festivals, fireworks displays, ice-cold watermelons, and long evenings when some wear *yukata*, the light summer kimono, as they stroll through the festive temple grounds.

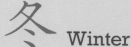 # Winter

Japan is such a long archipelago—it would stretch the length of California—that the coldness of its winter varies from place to place. Hokkaido is often snow-bound, but it never snows in Okinawa. Tokyo, the capital in the middle of the island chain, has a few snowfalls a year, but it is rarely colder than, say, Atlanta, Georgia, which is on the same meridian. But everywhere in Japan winter is as celebrated as the other seasons, and its still, bare, solemn beauty is much praised. To sit in an outdoor hot-spring pool, under the falling snow, drinking a cup of warmed sake — this is how to appreciate winter.

秋 Autumn

After the lingering summer—often into late September — comes the Japanese fall, often thought the most beautiful of all the seasons. Slowly, through October and November, the leaves become rich hangings of russet and gold. Red maples reflect the sun, and the tawny yellows of oak and chestnut drape the hills. Just as the cherry blossoms are thought most beautiful when they drop, their petals spiraling through the air, so the gradual coloring of the foliage is much admired as a sign of necessary evanescence, a temporary death which gives rise to new life. Then, as winter nears, the last leaves fall and the sun clouds over.

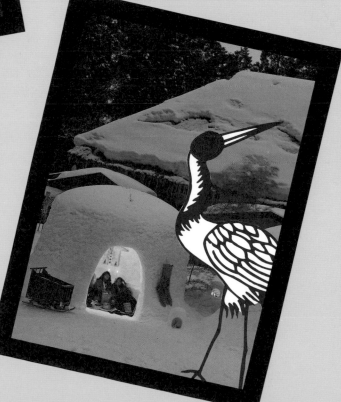

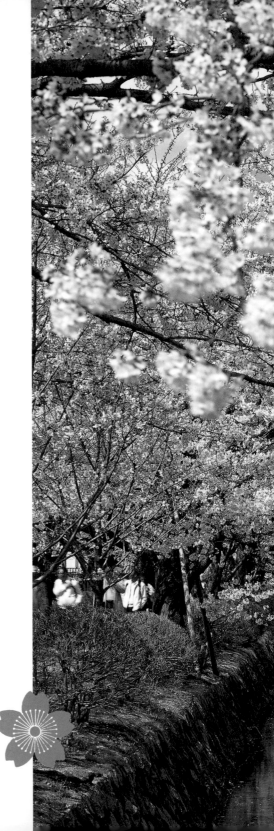

春 **Spring**

The Flowering Cherry, Symbol of Japan

Although there are 300 varieties of cherry trees, the most popular is the *somei yoshino* (*P. yedoensis*), which is said to reflect such traditional values as purity and simplicity, and its delicate color is often contrasted to the flamboyant Chinese peony. It is likewise praised for its ephemerality since its blossoms last only a few days. Japanese classical literature is full of the drifting, falling, dying cherry blossom. During this brief season people crowd to view them as here in this scene from late March, at the peak of the season, along the so-called "Path of Philosophy" behind the Nanzenji Temple in Kyoto.

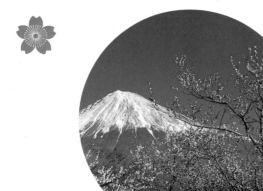

Mount Fuji, Japan's National Emblem

Mount Fuji, Japan's highest peak (3,776 m / 12,385 ft), unveils itself in the spring as the snows of winter melt and the blossoms appear. The cherry and the persimmon together bloom under the enormous volcanic cone which has become the symbol of Japan itself. Around the skirts of the mountain lie the Fuji Five Lakes—Yamanakako, Kawaguchiko, Saiko, Shojiko, and Motosuko. Further east is the Fuji-Hakone-Izu National Park, with its famous spas, crowded in the spring with bathing tourists who have come to view the blossoms and Fuji itself.

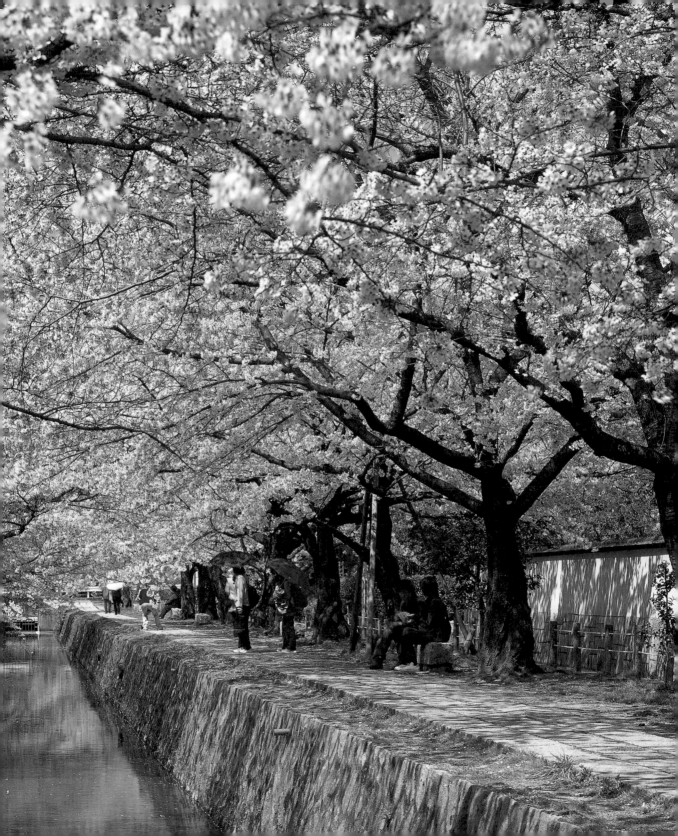

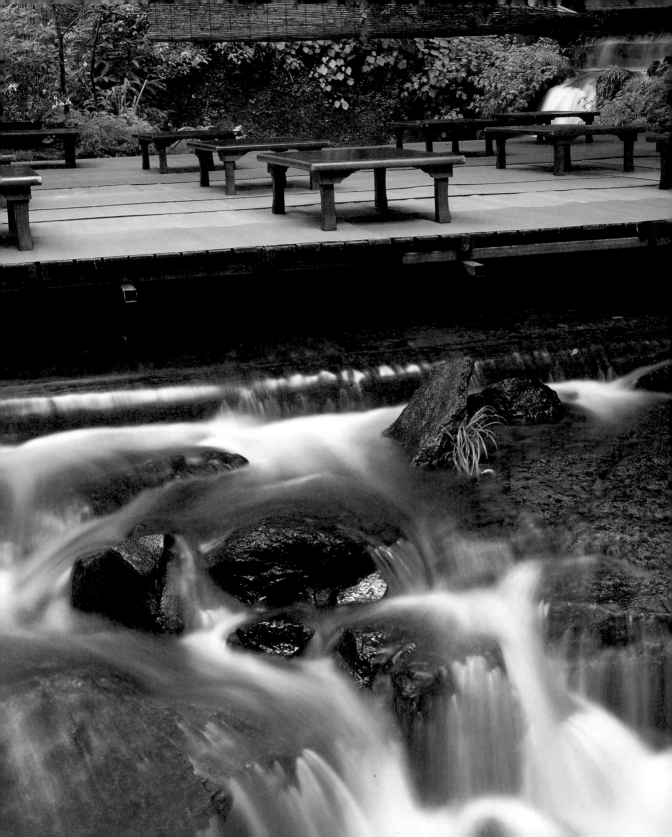

The Contrast of Japan's Seasons

The shifting seasons change the face of Japan. Mount Fuji, snow gone, rises into the summer sky. Still an active volcano, Fuji last erupted in 1707 when even Tokyo, 100 kilometers (62 mi) away, was covered with thick volcanic ash. It is not surprising that the mountain should be regarded with awe and seen as sacred. But it is also one of the world's most beautiful mountains, particularly in the summer when it is surrounded by green rice paddies, groves of verdant trees, and fields of fiercely orange sunflowers.

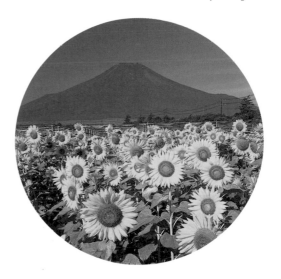

夏 Summer

A Combination of Rocks and Streams

Summer also means water — rivers, brooks, springs, rain, and waterfalls. In the hot months there is a new appreciation of cooling streams, as here, a resting place on Mount Kibune, north of Kyoto. It is the site of Kibune Shrine, dedicated to the god of rain. Amid the famous cedar forests, mountain streams form rivulets that grow to streams and rapids. Here and there are resting places, such as this at Kawayuka where refreshments await the summer traveler just down from the modest heights of the mountains.

秋 Autumn

The Metamorphosis of Colors

Viewing the cherry blossoms is so deeply ingrained in Japanese culture that the activity even has a name. It is *hanami*. Likewise, the change in autumn colors is so prized and valued that there is a name for it, too. It is *koyo*. From late October on, forests are filled with people looking at and talking about the transformations in the foliage. And this can be truly spectacular, just as fantastic as are the blossoms of the plum or the cherry. Here is a deep grove of red maples near Kyoto in full transformation.

Summer Below, Winter Above

With autumn, Mount Fuji changes yet again. There is a sprinkling of winter snow at the peak, but down below it feels like late summer as the forests turn gold at the approach of autumn. Shaped by the mountain winds, the trees stretch skyward, showing all the shades of fall—crimson, yellow, deepest brown— standing out clearly against that cerulean blue which the sky achieves only at the end of the year. The viewing of autumnal leaves is nearly as much a national pastime as are the expeditions to see the flowering cherry.

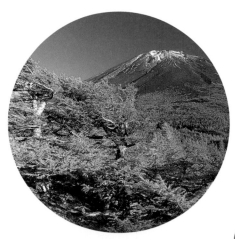

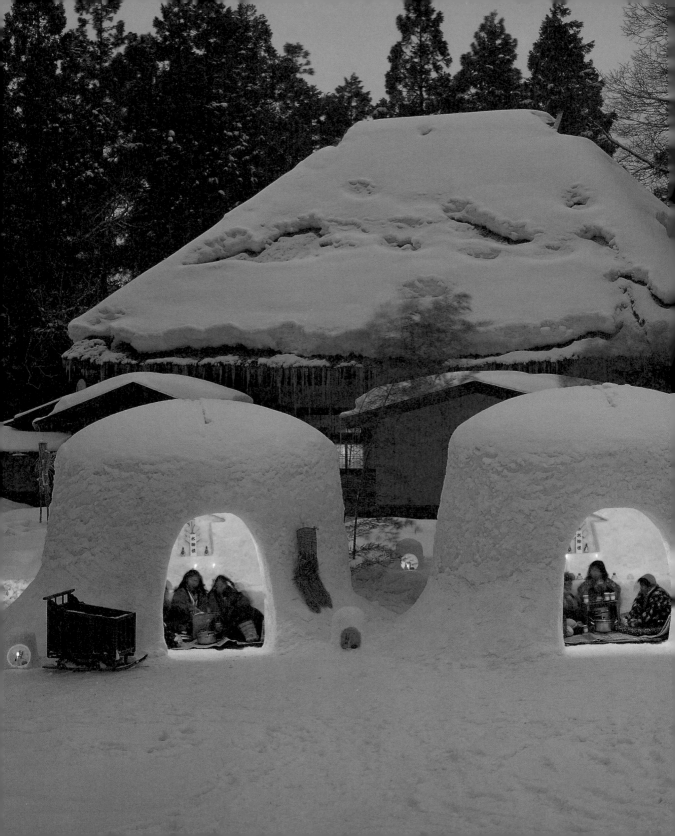

冬 Winter

The Snowy North

Though Japan has many festivals in spring and mid-summer,
the long winter seems most enlivened by its festivals.
There, in the cold and the snow, people parade and dance, eat and
drink, as though to both celebrate winter and keep its extremes at bay.
In the little town of Yokote in the far north of Akita Prefecture,
in the middle of January, small igloo-like snow houses called
kamakura are built, and in them the local children play, have
tea parties, and revel in the freshness that only winter can bring.

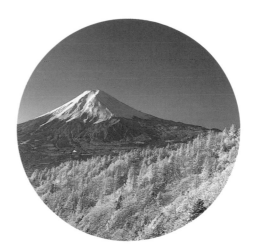

Fuji's Regal Season

Japan's deep winter always brings snow
to Mount Fuji and to the plains which surround it.
The time when one is allowed to climb the mountain is
long over, and snow covers the observation huts at its peak
and coats with ice the forests on its flanks. It is during
the winter that Fuji (often covered by clouds during the
other seasons) can be seen clear and enormous on the horizon.
This is the way it was pictured by such artists as the printmakers
Hokusai and Hiroshige over 150 years ago, and it is the same today.

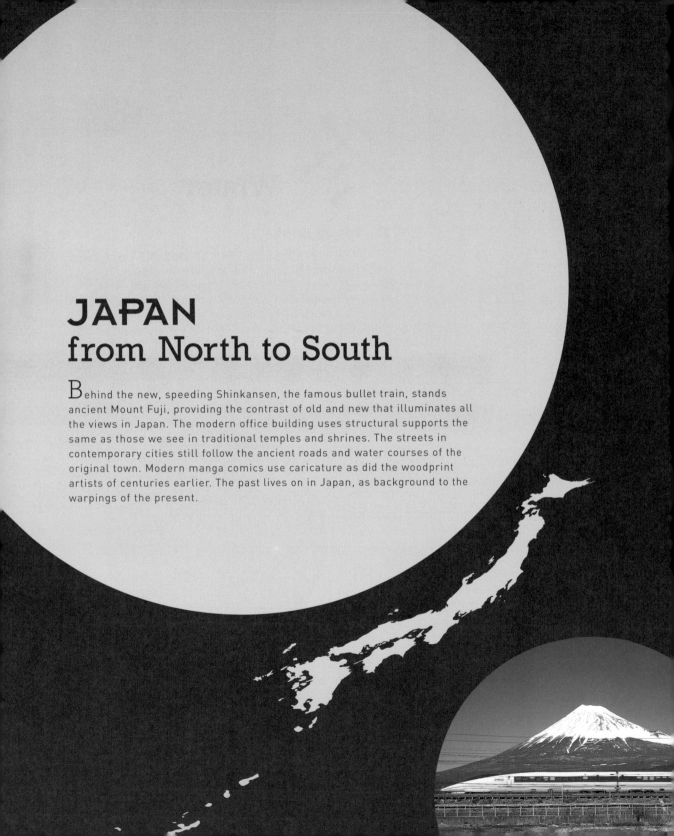

JAPAN
from North to South

Behind the new, speeding Shinkansen, the famous bullet train, stands ancient Mount Fuji, providing the contrast of old and new that illuminates all the views in Japan. The modern office building uses structural supports the same as those we see in traditional temples and shrines. The streets in contemporary cities still follow the ancient roads and water courses of the original town. Modern manga comics use caricature as did the woodprint artists of centuries earlier. The past lives on in Japan, as background to the warpings of the present.

HOKKAIDO
北海道

HOKKAIDO

The northernmost and second largest of Japan's four main islands, Hokkaido is known for its rugged mountains, its large lakes, and its vast virgin forests. The name Hokkaido, which first came into use in 1869, means "Northern Sea Circuit," and indicates the uses which the ruling central government found for it. The land, hitherto held by the indigenous Ainu and not originally considered a part of Japan proper, was firmly annexed by 1886, becoming the northernmost of Japan's prefectures. Hokkaido does not look like "Japan," if this means a preponderance of mountains and hills spotted with occasional densely populated valleys and plains. Rather it resembles stretches of Canada or Siberia and is certainly just as scenically spectacular. Consequently, tourism, both domestic and foreign, is a major source of income.

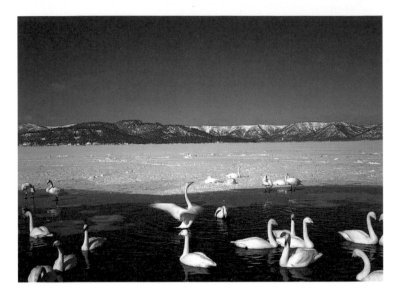

Winter Water Birds

Among the most lovely of the water birds which summer in Hokkaido are the wild swans of Lake Kutcharo. These appear yearly with the coming of spring, having flown long distances from their native nesting grounds. Also around Kutcharo, as well as Lake Akan and several other places, live the indigenous Ainu, who were residents of Hokkaido long before the Japanese came. Forced early to assimilate, given Japanese names, and forbidden to use their own language, they are now few indeed, though there are sporadic attempts by the Ainu to preserve their language and restore their ancient culture.

Land of Ice and Snow

Hokkaido is separated from Honshu to the south by the Tsugaru Strait and bounded by the Sea of Japan on the west, the Sea of Okhotsk on the northeast, and the Pacific Ocean on the south and the east. The climate is both colder and drier than the rest of Japan, producing not only snow but also blankets of ice. Hokkaido is the only place in Japan where the sea freezes over, as in the scene here from the shores of the Sea of Okhotsk. There is an abundance of wild life in Hokkaido, both on land and in the surrounding seas: whales and bears, porpoises and foxes, herrings and rabbits.

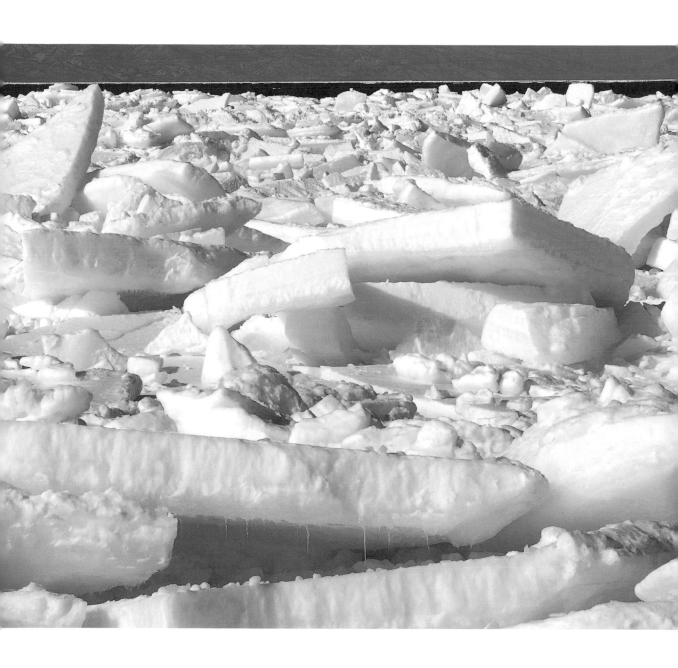

Marsh and Meadow

Much of Hokkaido is marshland, as in this stretch near Kushiro, a town on the south coast of the island. Just as Kutcharo has its lake and its swans, the waterlands of Kushiro also have their winter visitors. There is, at nearby Tsuruoka, a sanctuary for the rare red-crowned white crane. These beautiful birds, once near extinction but now returning in some numbers, prefer marshlands and meadows where they can fish and hunt for small creatures such as frogs or voles. When the marshlands are drained, as they now increasingly are, to make more land for farming, then the cranes and most other creatures leave.

The Wet Lands

Hokkaido, compared with the rest of Japan, is a land of lakes. Deeply scarred by the retreating glaciers, pitted by even earlier volcanic craters, the land became a natural container for a whole collection of lakes: the beautiful Mashuko, claiming to hold the clearest water in the world; the caldera Kutcharoko; and the mysterious Akanko, where live the curious underwater *marimo* weed, an often quite large sphere of green algae. Below is the beautiful Notoriko, a lake which in the autumn is famous for its russet rushes.

Fields of Flowers

The Japanese think of Hokkaido as the most bucolic part of their countryside. It is seen as rustic in a way long gone from other parts of the archipelago. And though it has its modern industries, its products are largely rural. There is Hokkaido butter and cheese, all sorts of dried marine products, probably the best edible seaweed in Japan, and field after field of commercially grown flowers—whole blankets of tulips, fields of daffodils, acres of chrysanthemums. Here we see a field holding swathes of ornamental poppies.

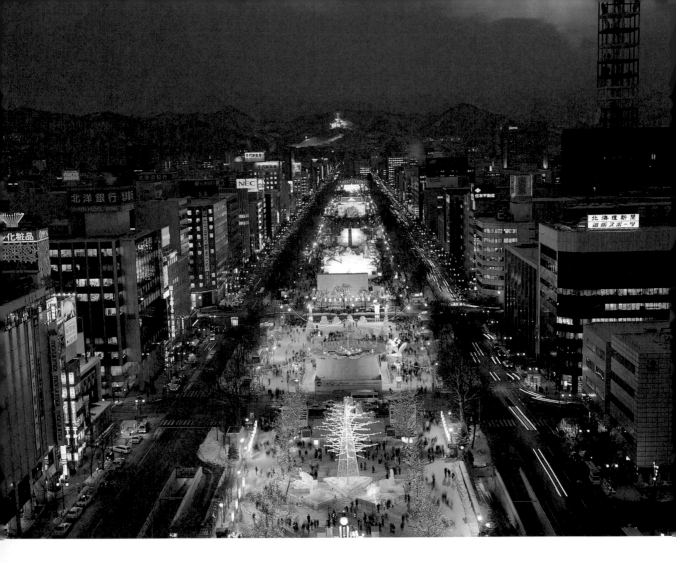

City in the Snow

Sapporo itself is laid out like a Western city. It has streets at right angles and an address system that makes sense to foreigners, unlike most of the rest of Japan. It was founded in 1869 and has many gardens, and the park-like O-Dori, which is the main street seen above, is the widest thoroughfare (105 m / 344 ft) in Japan. The most famous festival is the Yuki Matsuri, held in the first weekend of February, during which the O-Dori is filled with enormous snow sculptures, such as those at right representing the coming of both Russia and the West.

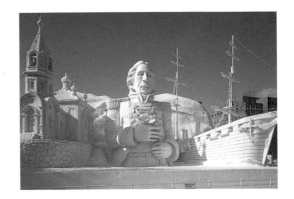

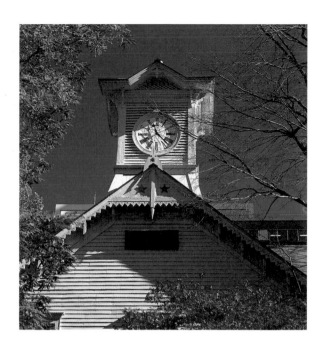

Remnants of the Past

When foreigners began coming to Japan in any number during the middle of the nineteenth century, it was the Americans and the English who originally investigated the coastline of Japan. It was the Russians, however, who first came to Hokkaido, and their influence is visible yet. The most famous remnant is the clock tower in the capital of the island, Sapporo. Though the clock is American made, the structure itself is the only Russian-style building remaining, and has been a well-known landmark since 1878.

Traces of History

As the mainland Japanese gradually settled into Hokkaido, they brought with them their architecture and their artifacts. This is an aerial view of the Goryo-kaku, the only castle in Japan to be built in a European style. It was finished in 1864 — just in time to be used during the 1868 revolution. The supporters of the feudal Tokugawa government resisted the new Meiji government for more than six months before giving in. Now only the walls and moats are left, and it has become a public park. Its famous cherry trees make Goryokaku a favorite spot in spring.

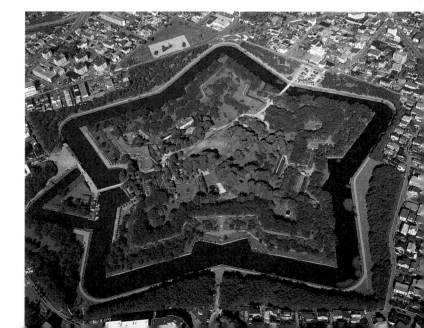

The Ainu of Hokkaido

Remnants of Hokkaido's ancient, pre-Japanese past are kept alive in the form of festivals, often featuring bits of local folklore. One such is the Marimo Festival on Lake Akan, in which Ainu in full native costume consecrate the *marimo* algae clusters found there (see below). Another is the Orochon Fire Festival which celebrates an even earlier people, the Gilyaks, about whom little is known, and which resurrects their supposed rites to ensure good hunting and plentiful crops. Songs, dances, and shamanistic ceremonies are offered against a background of blazing log fires.

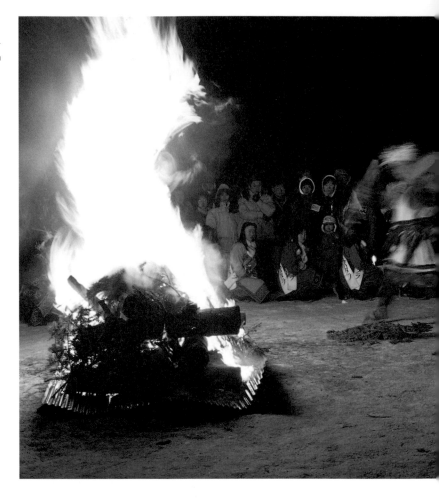

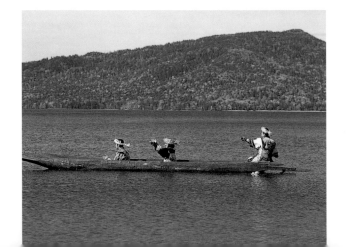

The Past Transformed

Another Hokkaido city is Otaru, a port town which early flourished both because it was a shipping center for the Ishikari coalfields and because the first railway in Hokkaido, opening in 1880, connected Otaru with the capital. With the decline of Hokkaido's mining and fishing industries, Otaru has transformed itself into a tourist town, featuring renovated warehouses, art galleries, coffee shops, and old canals turned to scenic uses. It is also a convenient entryway into nearby ski resorts on Mount Tengu and is very near the spectacular Shakotan coast.

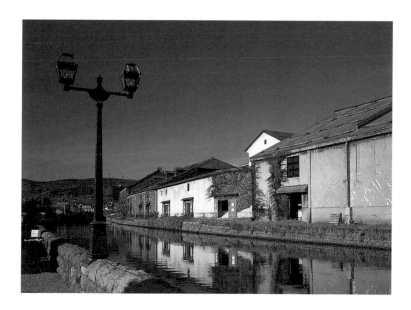

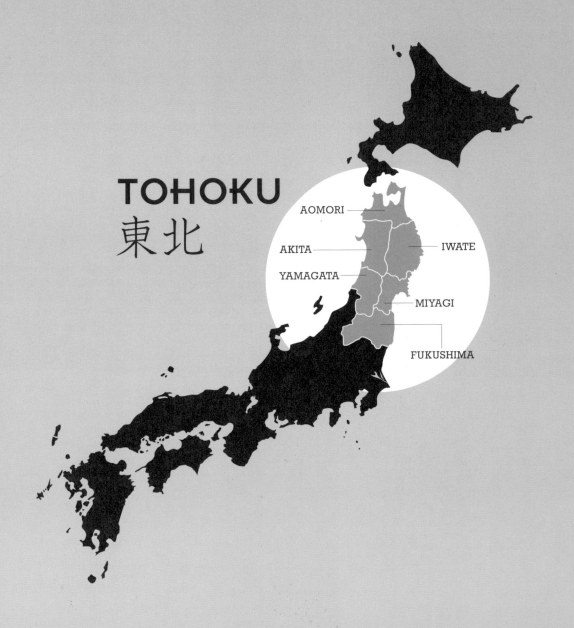

TOHOKU
東北

AOMORI

AKITA

YAMAGATA

IWATE

MIYAGI

FUKUSHIMA

Tohoku comprises almost the entire northern part of the main Japanese island of Honshu—the prefectures of Aomori, Iwate, Akita, Yamagata, Miyagi, and Fukushima. It is where the traditional life of the country is best preserved. Mostly rural, this mountainous and often snow-bound region still has its own accent, whether it be in the crafts, the festivals, the dwellings, or the speech itself. Twenty percent of Japan's rice comes from the area, which is commonly thought to retain the warm, small-town attitudes of an earlier time.

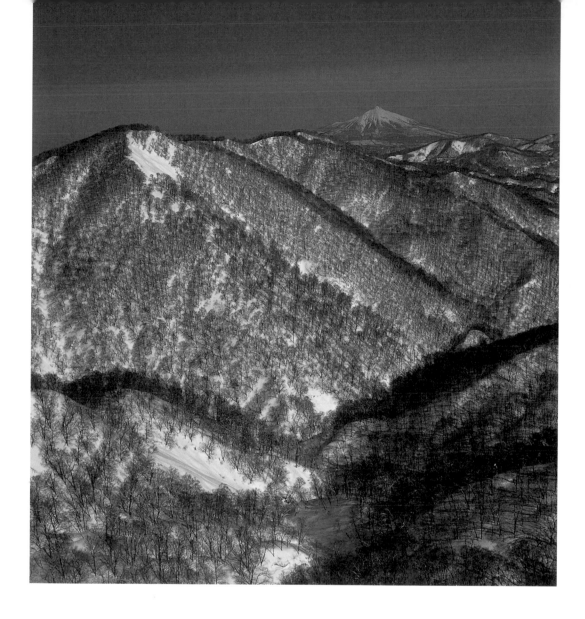

The Shirakami Mountain Range | AKITA

The Tohoku region is largely mountainous, and one of its more famous mountain ranges is the Shirakami Sanchi, which runs along the border between Aomori and Akita prefectures. Part (16,971 hectares) of these mountains was designated a World Heritage Site in 1993. It contains vast, virgin forests of Japanese beech, of the type that used to cover much of the Tohoku region. There are 500 plant species, 14 species of medium to large mammals, and over 2,000 insect species. Here we see part of Shirakami Sanchi in the foreground, with Mount Iwaki, which is not part of the range, in the background.

Rice Paddies | AKITA

The rice-fields of Tohoku are important to Japan. and they continue to shape the lives of those who work them. Even now, though highly mechanized, the planting and reaping of rice is hard work. This labor, it is said, created the typical Tohoku character—strong and stubborn. In earlier times it was up at dawn, to bed at sunset, and nothing but the hardest of field labor in between. This created a people known even now for their unflagging energy.

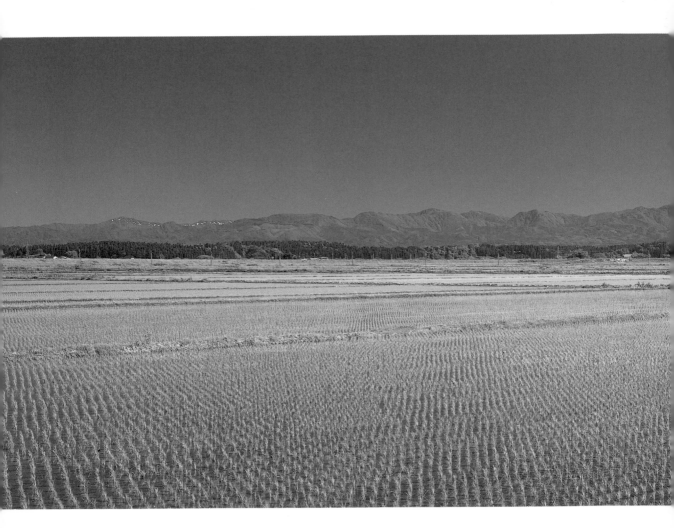

Tohoku Cuisine | AKITA

This energy is fueled by one of the country's most nourishing cuisines, known for its one-pot *nabe* dishes. These are stews which combine the rural flavors of Tohoku, mixing fowl or fish, meat and vegetables, to create native ragouts which are said to taste of all the flavors a Japanese associates with the *furusato*, his or her home town. They are often served with *kiritampo*, rice-on-a-stick, roasted on the fire. Though the fare was apt to be frugal during hard times, the warmth and hospitality of old-time Tohoku was legendary, even now living on in the comforts of its hot-spring baths and the satisfactions of its cuisine.

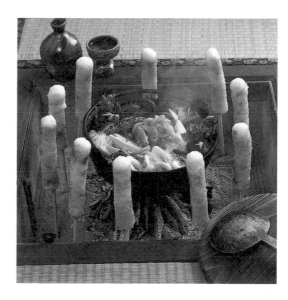

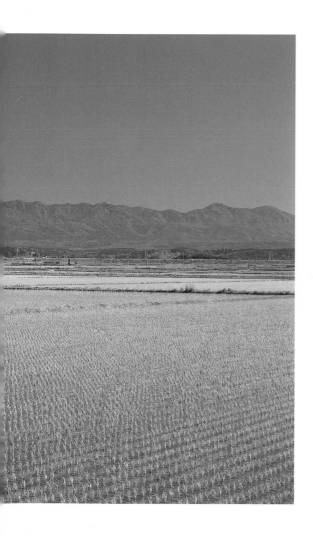

Tohoku Festivals | AOMORI

Tohoku not only works hard, it plays hard as well. One of the most strenuous and spectacular of Japanese festivals is to be seen in the cities of Aomori and Hirosaki during the first week of August. Enormous floats holding gigantic paper images of legendary figures, all of them lanterns illuminated from within, are wheeled about the nighttime streets, followed by thousands of townspeople singing and dancing. This is the fabled annual Nebuta (or Neputa) Festival, one of the most popular in Japan.

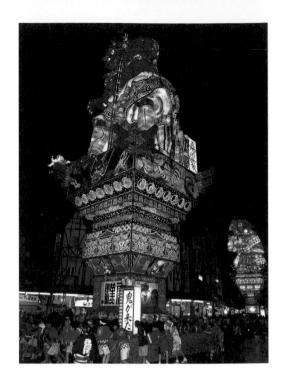

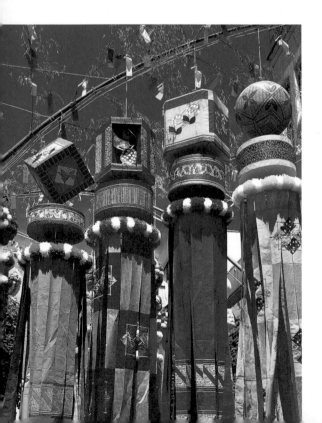

The Tanabata Festival | MIYAGI

The Nebuta Festival is said to be a variant of the even more popular Tanabata Festival, a midsummer (August 7) event seen at its fullest in the Tohoku city of Sendai and the Kanto city of Hiratsuka. Bamboo branches are decorated with talismans and other ornaments, and long strips of paper are often graced with poems. The origin of the celebration is the annual meeting of two celestial lovers who could meet only once a year, but the purpose is also plainly purification. The branches, along with figures of animals and men, are set afloat on a river.

Nebuta Floats | AOMORI

After the dancing and the singing, the floats are thrown into the sea, as is seen fitting for a rite whose main purpose is purification. Many Japanese festivals share this aim, but not many of them are as spectacular as Tohoku's. The act of purification is also seen as warding off illness and bad fortune — releasing them to "float off to sleep." *Nemurinagashi* is the local term for this, and indicates both good will and good riddance. It is from this word that the Nebuta Festival derives its name.

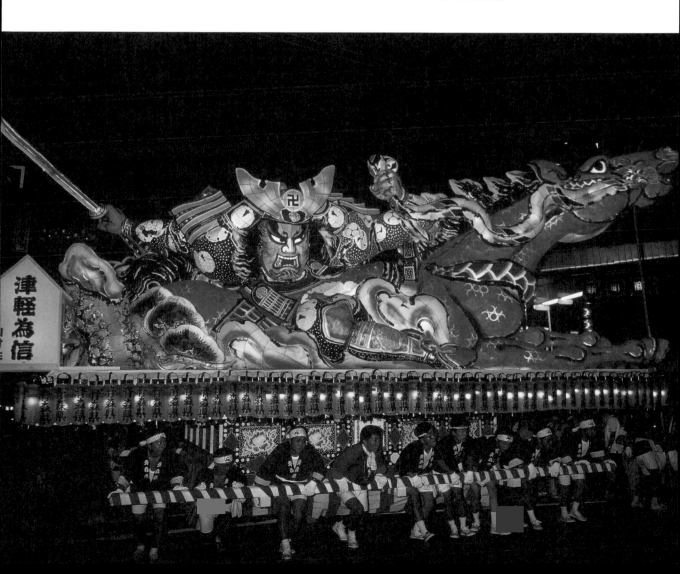

The Frozen North | YAMAGATA

Snow is very much a fact of life in Tohoku. It can be celebrated, as in the various snow festivals of the far north, including that in Sapporo. It can be appreciated, as in the snow-viewing parties held as early as the Nara period (710-794). But this was only in temperate Honshu. There is no snow-viewing in Tohoku. It is too ubiquitous, makes life too difficult, and it can freeze a forest.

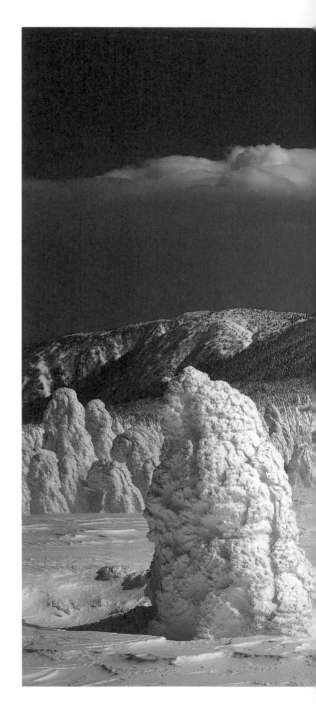

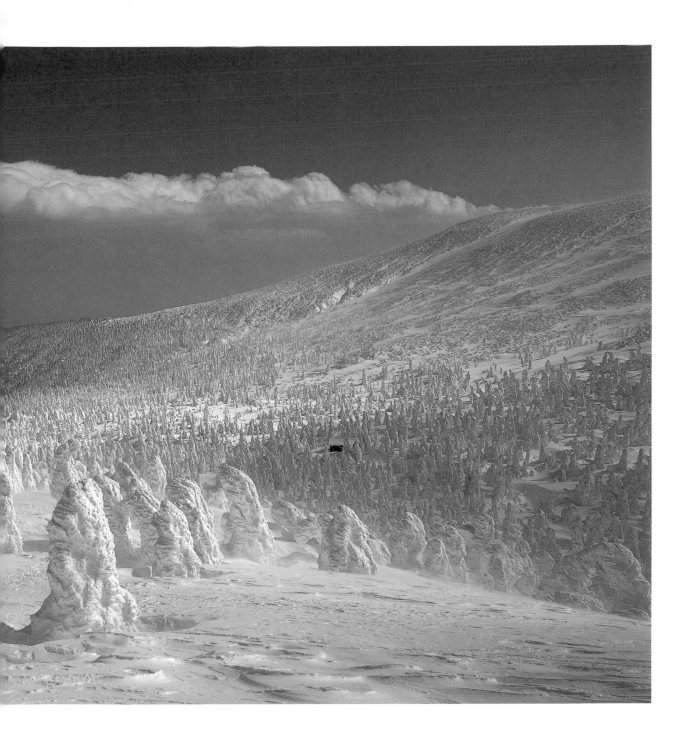

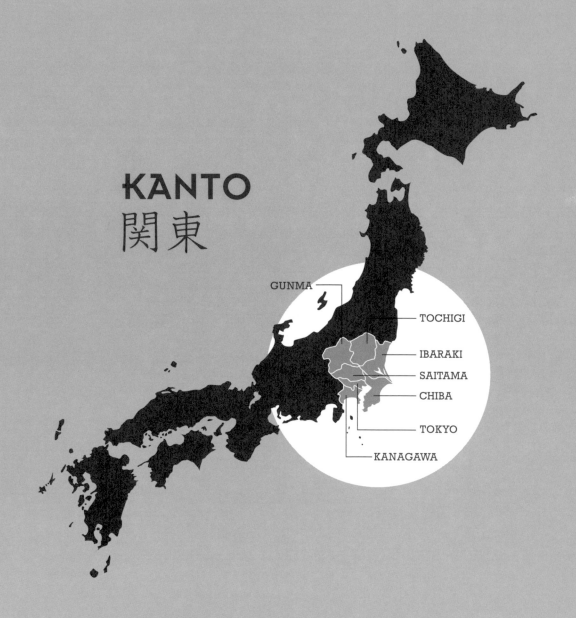

KANTO
関東

GUNMA
TOCHIGI
IBARAKI
SAITAMA
CHIBA
TOKYO
KANAGAWA

The middle section of the main Japanese island of Honshu is the Kanto region. It comprises Tokyo and the prefectures of Chiba, Saitama, Kanagawa, Gumma, Ibaraki, and Tochigi. It is Japan's most heavily populated region and is the political, economic, and cultural center of the nation. Dominated by the great Kanto Plain, its development was fairly recent in Japanese history. Edo, the political center of Japan for over 250 years, was not built until 1604 and had its name changed to Tokyo only in 1868 when it became the capital.

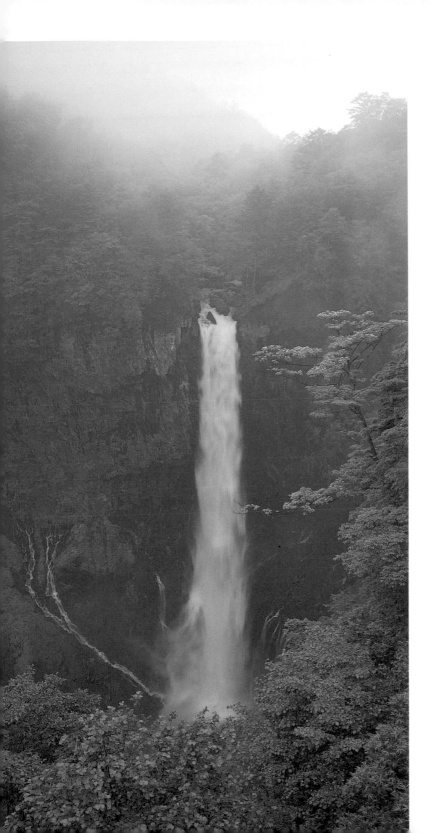

The Kegon Falls | TOCHIGI

It is in the Kanto region that some of Japan's most famous sights are located. Among them certainly is Nikko, an enormous national park and one of the most popular. Here is found the mausoleum of Tokugawa Ieyasu, the founder of the Tokugawa shogunate. Here is beautiful Lake Chuzenji, and pouring out of it is the Kegon Falls, one of Japan's most famous waterfalls and certainly one of its most visited. There is even an elevator to take you to the bottom of the gorge for a view of the descending water.

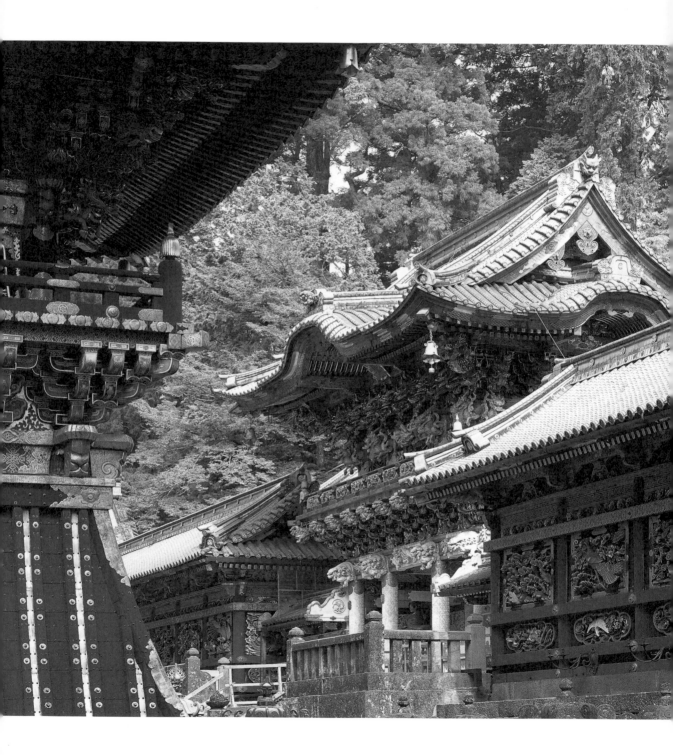

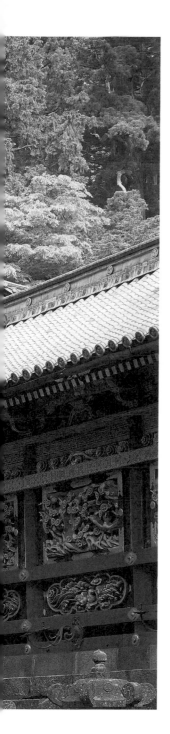

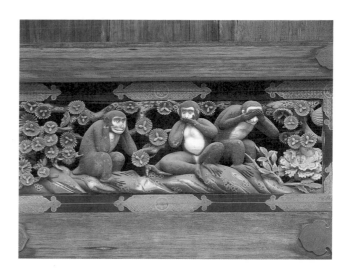

The Nikko Mausoleum | TOCHIGI

The Toshogu, which is the mausoleum of Tokugawa Ieyasu, is a complex of highly ornate shrine buildings and gateways, completed in 1636 and designed in the roccoco Chinese style then fashionable. Among its attractions is the Yomeimon, the main gate (left). Now designated a National Treasure, it is decorated with inlays, black lacquer, and gold leaf. Equally famous are a number of carvings, including the "sleeping cat"(below) and the world-famous "hearing, speaking, and seeing no evil monkeys"(above).

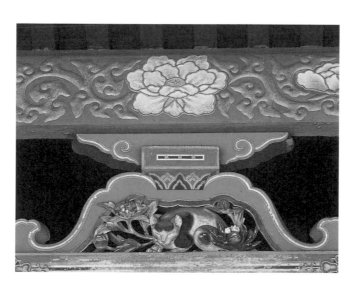

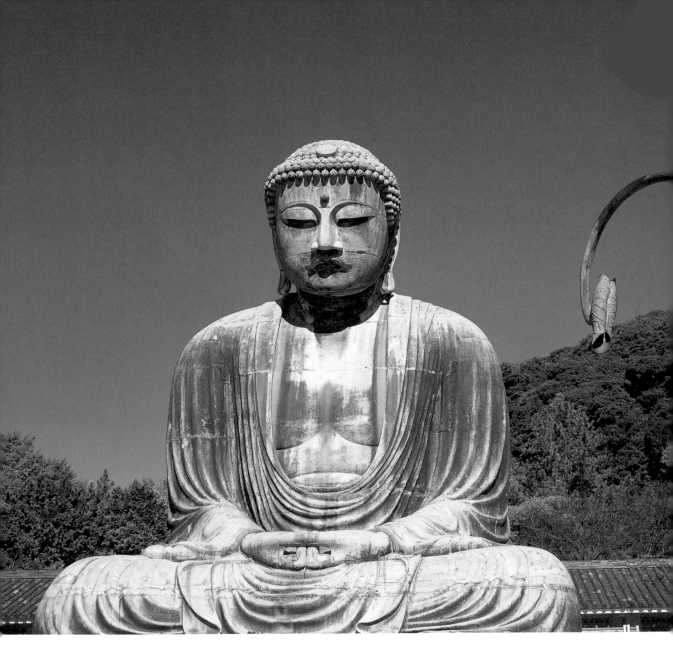

The Great Buddha of Kamakura | KANAGAWA

Another Kanto collection of famous sights is Kamakura. Its most famous single sight, to be found at the Kotokuin Temple, is the great bronze image of the Amida Buddha, 11.5 meters (37.7 ft) high and weighing 100 tons. Cast in 1252, it was originally housed in an equally enormous wooden temple, but a 1495 tsunami swept this structure away and the Buddha has ever since been meditating under the open sky. The hands are in the mudra position expressing true faith. Seen under the skies of Kamakura and against the hills of the Miura Peninsula, the Buddha expresses a palpable oneness with nature.

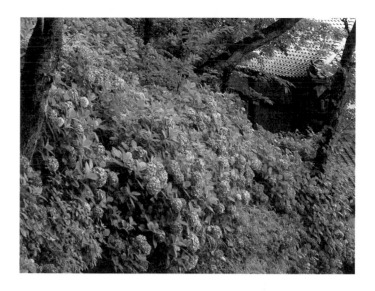

Hydrangea at Hasedera | KANAGAWA

Kamakura not only has the Hachiman Shrine, the Great Buddha, and the Hase Kannon; there are also the myriad sights of nature, such as this famous stand of hydrangea on the grounds of Hasedera Temple, famous as well for housing the huge nine-meter figure of Kannon, Buddhist Goddess of Mercy, carved from a single camphor log, supposedly in 721 AD. Here, as with the cryptomeria forest around Nikko, it is often the nature surrounding the great sights that lend them a special dignity.

Chinatown | KANAGAWA

Yokohama has long had a tradition of internationalism, becoming in 1859 one of the few ports open to foreign trade. Its Chinatown is famously unique (Tokyo has none), and the food, it is said, is just as good as the food in China itself. There is also a good ethnic mix in Yokohama—not only the Chinese but enclaves of many other nationalities as well.

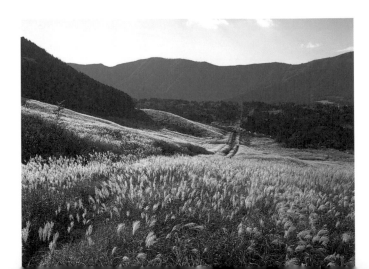

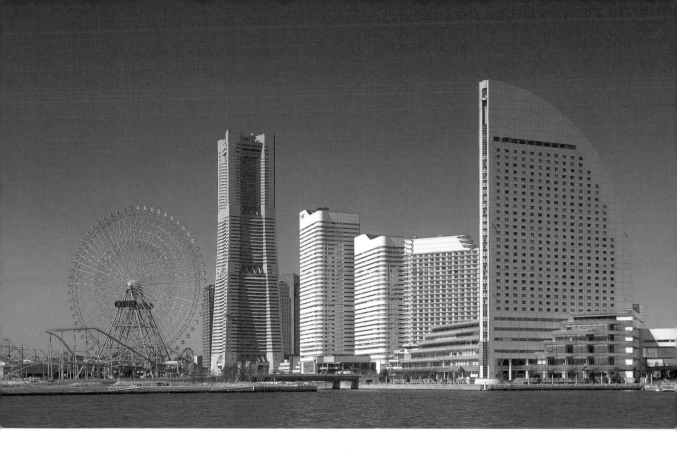

Yokohama's Minato Mirai | KANAGAWA

Yokohama, originally merely the port of nearby Tokyo, is now the second largest city in Japan. Among its more recent efforts to further energize itself is the construction of an enormous waterfront complex, the Minato Mirai 21, which contains hotels, restaurants, office towers, a first-rate art museum, and even a Ferris wheel.

The Highlands of Sengokuhara | KANAGAWA

At the edge of the Kanto region is Sengokuhara, the highland of Sengoku, some 700 meters (2,296 ft) above sea level. North of Lake Ashinoko, formed from the old volcanic crater of Hakoneyama, these plains were until recently wild and desolate, covered with grasses and marsh plants, home to the rabbit, the fox, and the pheasant. Now, however, civilization has encroached even here. There are golf courses, ice-skating rinks, convenience stores, and a few hotels, with many more on the way.

TOKYO
東京

TOKYO

Japan's capital, Tokyo, is one of the largest cities in the world. It covers an area of roughly 2,145 square kilometers (828 sq mi) and has a live-in population of over twelve million people—a number that swells dramatically during the day as people come into the city to work and to play. Though often subject to disaster—the 1923 Kanto earthquake, the 1945 American fire-bombing—Tokyo has always recovered, grown, prospered. Its skyline, dominated by Tokyo Tower, is devoted to the future as new and newer structures rear into view.

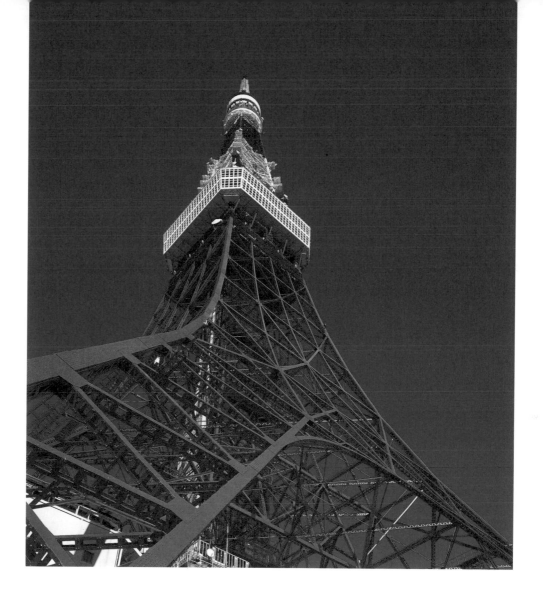

Tokyo Tower

Tokyo Tower, bright red and illuminated at night, has become as much a symbol of its city as the Eiffel Tower is of Paris. Completed in 1958, it rises 333 meters (1,093 ft) and has two observation decks and a broadcast antenna at the top. It also has one of the best views of the city. Though this view of Shinjuku was not taken from the tower, it gives an idea of the space and detail which such a high vantage point yields.

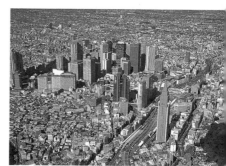

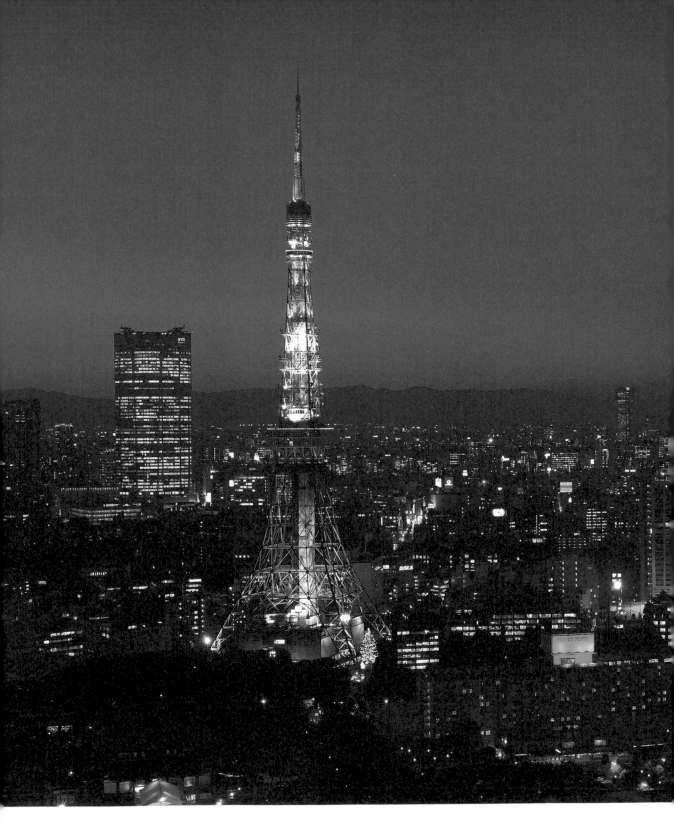

The City Hall

Tokyo Tocho (City Hall) is a 48-story (243 m / 797 ft) double-spired tower designed by Kenzo Tange, one of the founders of Japan's postwar architectural style. An elevator to the top takes less than a minute. The whole structure is a monument to the affluence of modern Japan.

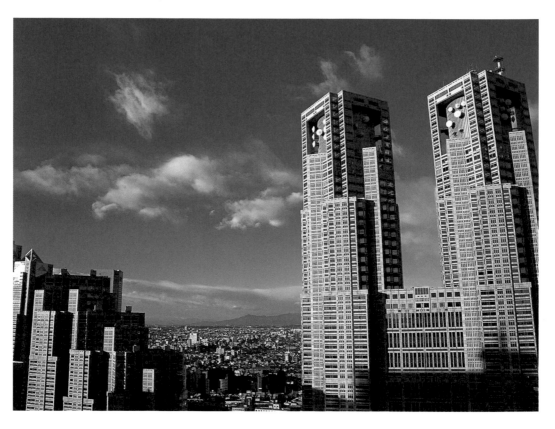

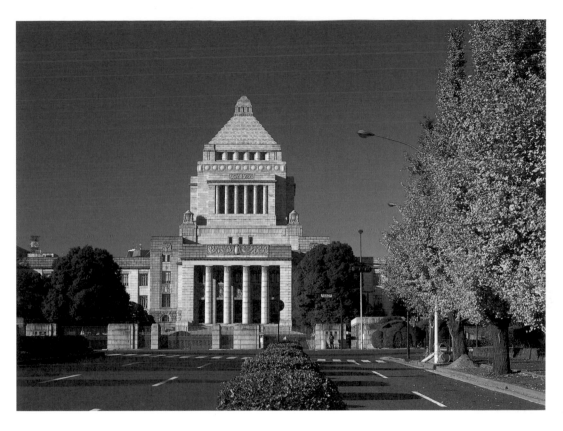

The Diet Building

If the City Hall, completed in 1991, is the center of the city government, the Kokkaigijido (Diet Building), completed in 1936, holds the legislative branch of the Japanese government and has proved a training ground for Japan's political leaders.

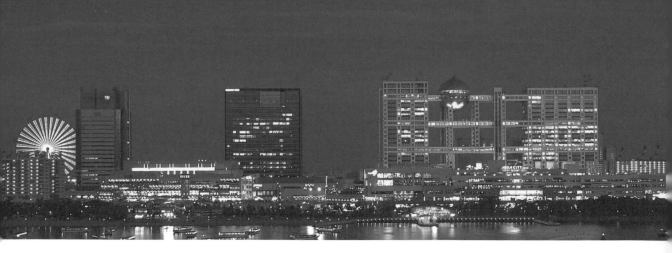

Odaiba

Rivaling Shinjuku is Odaiba (above), a large artificial island in Tokyo Bay, constructed of reclaimed land and now containing a number of massive new buildings which, in turn, hold hotels, restaurants, and entertainments.

Shinjuku

Shinjuku (below) is perhaps the liveliest of all the districts of Tokyo. Here is not only the City Hall but also most of the varied entertainments of the capital. It is the Night Town of Japan, and if Shinjuku does not have it, it probably doesn't exist.

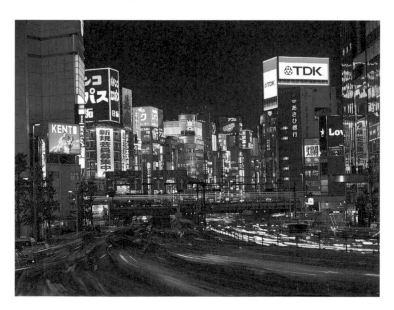

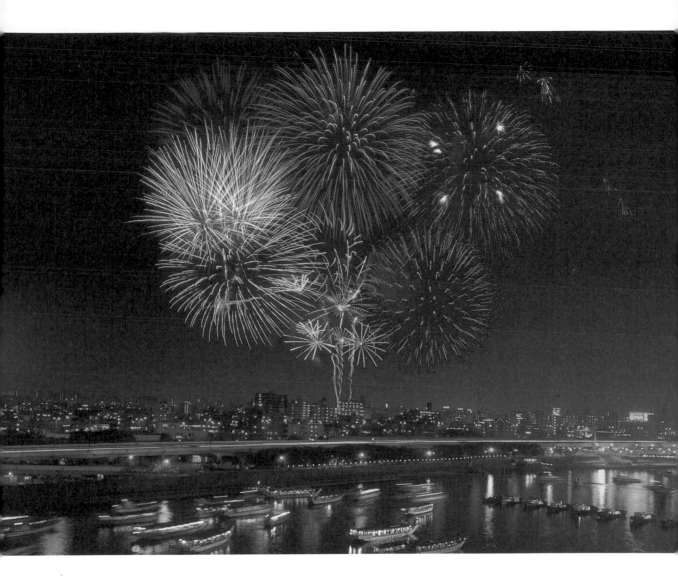

The Sumida River

Tokyo is the ancestral home of the old as well as the glittering new. Just as the Thames holds old London and the Seine preserves what is left of ancient Paris, so the Sumida River is home to such districts as Asakusa and Mukojima. It is also the place from which to view such traditional sights as the annual (August) display of old-fashioned fireworks. The river itself originates in the Kanto Mountains and flows through the eastern section of the city, to empty into Tokyo Bay.

Nihonbashi

The famous Bridge of Japan (Nihonbashi) was once so important that all distances in Japan were calculated from it. It was commemorated in some of the most famous of the wood-block prints. Now, however, commerce and convenience have much reduced it, and it languishes under a series of expressways.

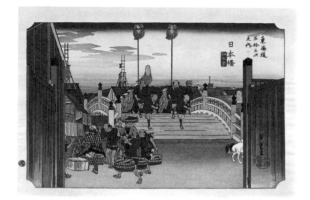

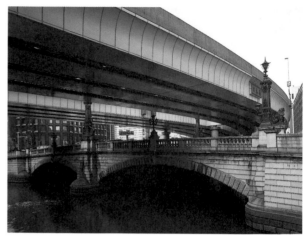

The Imperial Palace

In the center of Tokyo sits the Imperial Palace, surrounded by its extensive grounds and moats. The East Gardens are generally open to the public, but the inner palace is accessible only twice a year (January 2 and the Emperor's birthday). It is then that visitors can cross the Nijubashi Bridge, which has the distinction of being one of the most photographed places in Japan.

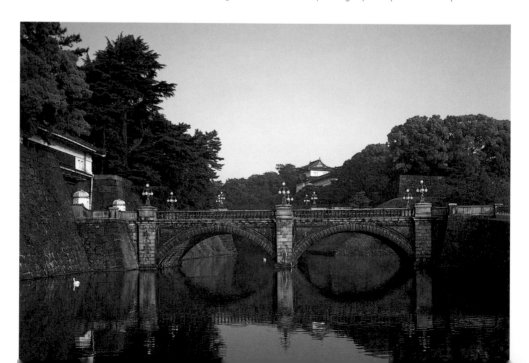

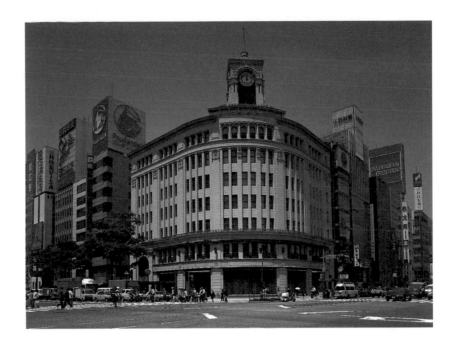

The Ginza

The Ginza is Tokyo's most famous shopping street, long compared to New York's Fifth Avenue, and the Ginza 4-chome crossing (seen above) is often called the center of the city. The name Ginza means "Silver Mint," for it was near here that the shogunal government minted its coin from 1612 to 1800. It later became the first Westernized part of the city and still retains its reputation for fashion and quality.

The Kabuki-za

Quite near the Ginza is the Kabuki-za, where Japan's traditional Kabuki drama is still performed. Completely destroyed during World War II, it has since been reconstructed and remains a major showplace for this 400-year-old art.

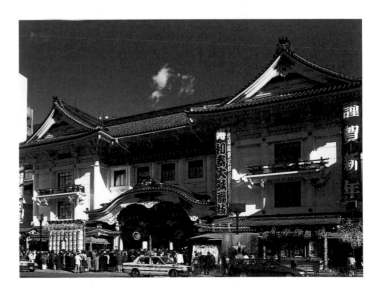

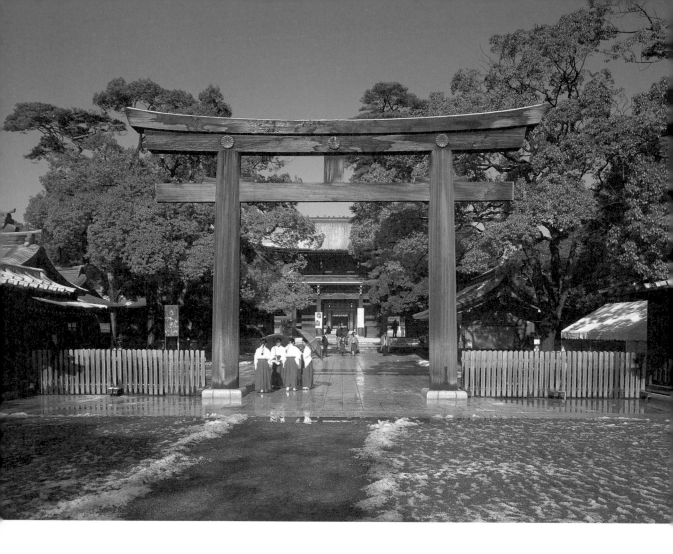

Meiji Shrine

Meiji Shrine is another imperial enclave in the middle of the city. The shrine is dedicated to Emperor Meiji (1852-1912) and his empress — though their remains are actually interred near Kyoto. The enormous *torii* gate is made of Taiwanese cypress, and the shrine was first completed in 1920. Destroyed in a 1945 air raid, it was rebuilt in 1958 with private donations. Besides being a national attraction, it is located in one of the most beautiful of the few natural parklands still left in the capital. In contrast to the noise and frivolity of next-door Harajuku, here all is peace and silence.

Asakusa

If Shinjuku is home of the new, Asakusa houses what is left of the old. Though nearly destroyed in the 1945 fire-bomb raids, it still retains some of the atmosphere of its prewar form. Among the attractions is the enormous Kannon Temple (Senso-ji) and its major entry, the Thunder Gate (Kaminari-mon), rebuilt in 1955, which features the mighty lantern seen here.

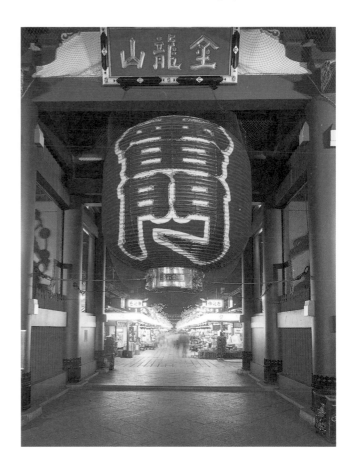

Nakamise

Stretching from the gate and its lantern is the Nakamise, a long street of shops leading to the temple itself. One of the stores selling rice crackers claims to be over 200 years old. Among the sundry goods sold here are old-fashioned boxwood combs and camellia oil for softer hair.

CHUBU
中部

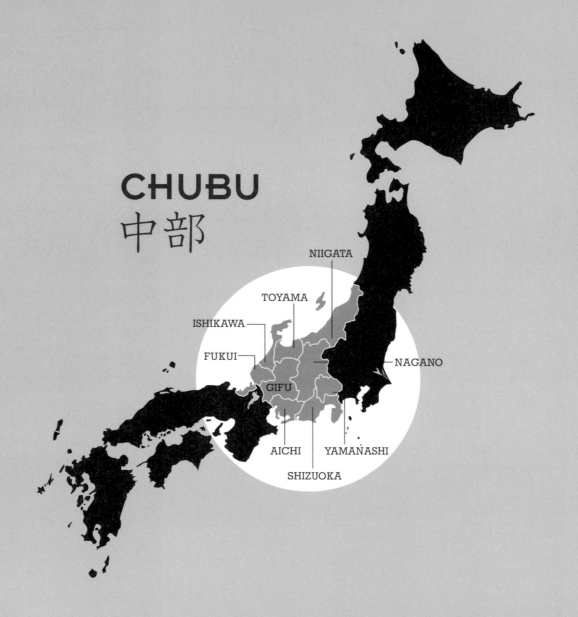

NIIGATA

TOYAMA

ISHIKAWA

FUKUI

NAGANO

GIFU

AICHI

YAMANASHI

SHIZUOKA

The area between the old capital of Kyoto and the military center of Edo, now Tokyo, is the central region of the island of Honshu, called Chubu. Largely mountainous, it contains some of Japan's finest natural scenery. There are the Japanese Alps and Mount Fuji itself, as well as many ancient roads and old post towns. Also in Chubu, untouched by wartime bombings, are the cities of Takayama and Kanazawa, as well as the modern metropolis of Nagoya. Here spring comes late and autumn early.

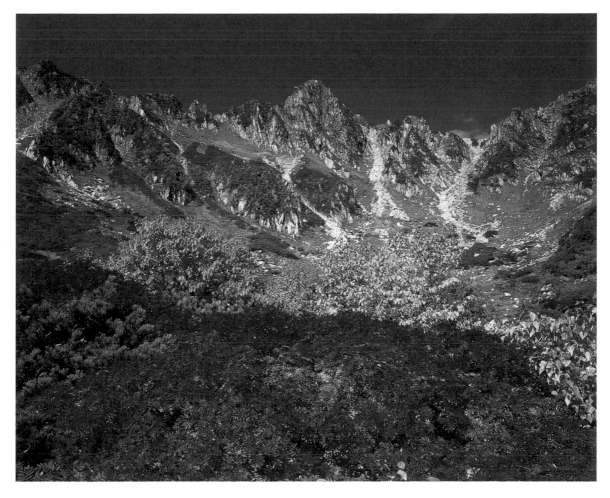

The Japanese Alps | NAGANO

The Japanese Alps fall within the Chubu region. They consist of three mountain ranges: the Hida, the Kiso, and the Akaishi, which are also referred to as the Northern, Central, and Southern Alps, respectively. Aside from Mount Fuji, it contains the highest mountains in Japan. There was no term for the entire range until it was noticed that foreign visitors referred to it as the "Japanese Alps," a term first used in a book published in 1896 and now a part of the Japanese language. Here we see a bit of the Alps near the scenic highland basin called Kamikochi, where the autumn foliage is particularly fine.

Mount Fuji | SHIZUOKA

Mount Fuji offers a stunning profile whether it is viewed during the autumn with persimmons in full fruit or at sunset when its form rises dark above the horizon. Beautiful though it is, Fuji is a demanding climb. It takes four or five hours even if you begin the ascent, as most do, from the fifth of the ten stations into which the path is divided. The mountain itself is really a great, sliding, cinder pile, and it is high enough to tax both the lungs and the heart.

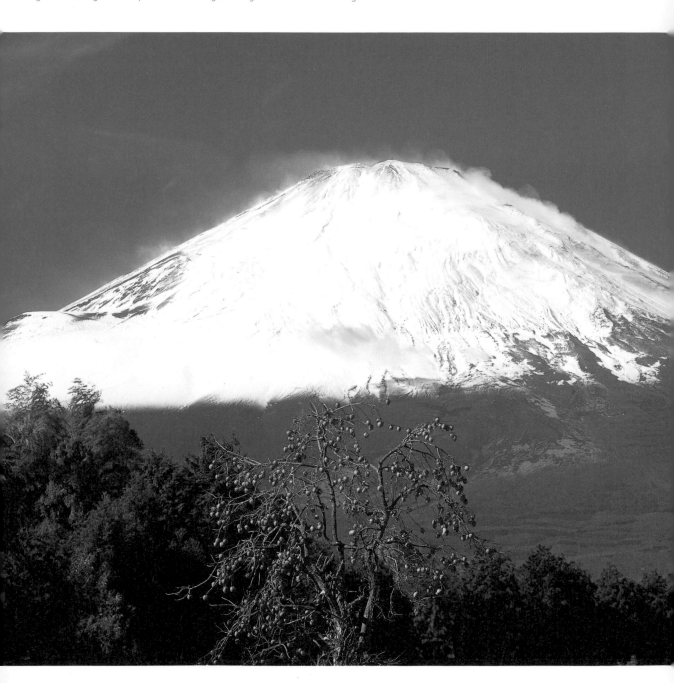

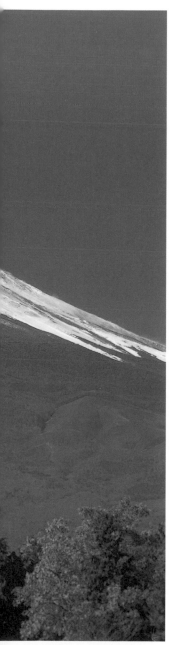

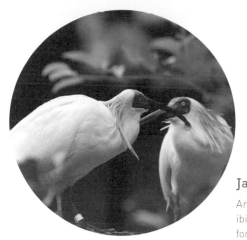

Japanese Crested Ibis | NIIGATA

Among Japan's many birds is the crested ibis, locally called *toki*. With its slim helon-like form and reddish hues, it has often appeared in Japanese prints and paintings. Now it is recognized as an endangered species. At the same time, breeding efforts with birds donated by China in 1999 have been successful, and today 80 ibises are waiting at the Sado Japanese Crested Ibis Conservation Center to be reintroduced into the wild.

Tarai Boats | NIIGATA

Taraibune are oval, wooden tub-like boats unique to the town of Ogi on Sado Island. Mainly operated by women, they were once used to collect *sazae* (wreath shells) and *awabi* (abalone) along Sado's rugged coastline. The boats are about 180 centimeters long, 140 centimeters wide, and 50 centimeters deep. Visitors are welcome to jump in and try the tubs out.

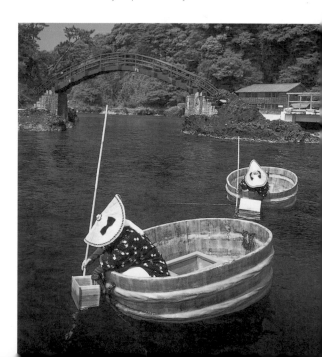

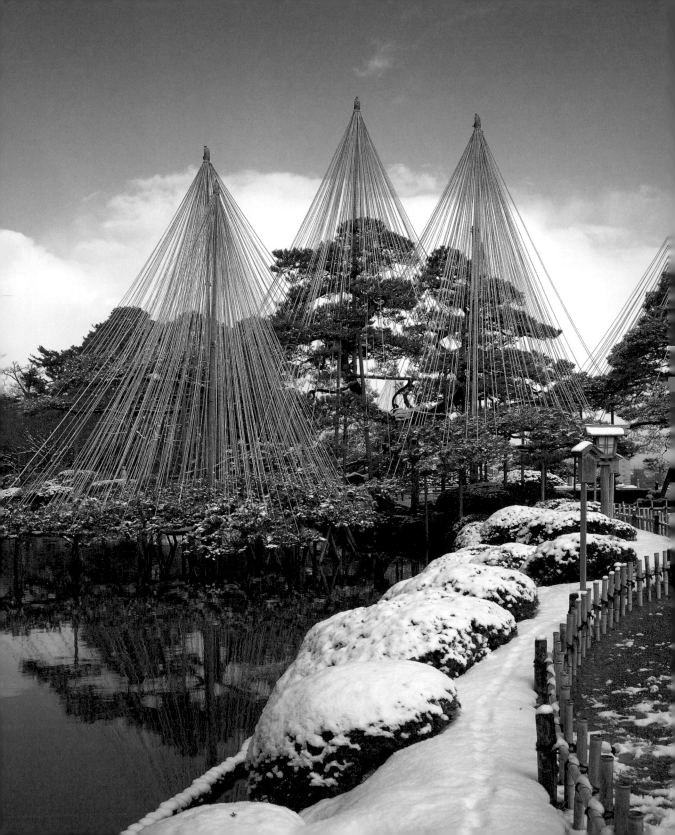

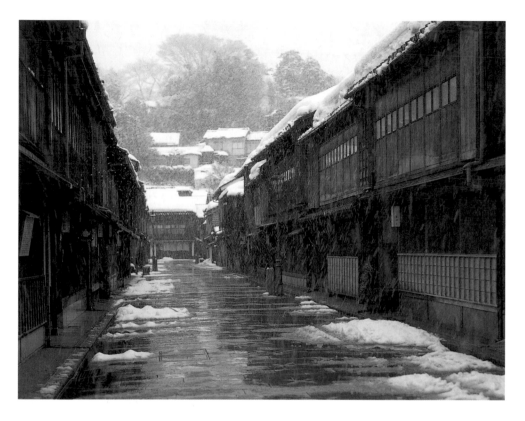

Kanazawa | ISHIKAWA

The city of Kanazawa escaped bombing during World War II, the only large city other than Kyoto to do so. Many old buildings have thus survived and whole districts are much as they were. There are sections of "samurai" houses and streets of merchants' dwellings.

The Kenrokuen Garden | ISHIKAWA

Among the great sights in Chubu is the famous garden of Kenrokuen in the city of Kanazawa. It was laid out in 1822 for the ruling daimyo, Maeda Narinaga, and is thought best seen in the snow.

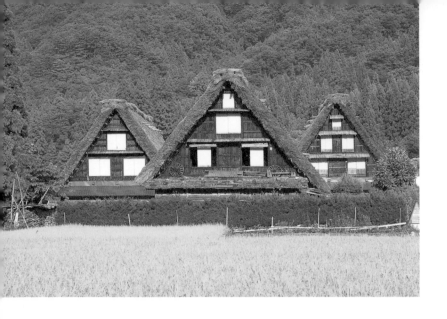

The Farmhouses of Shirakawa | GIFU

The village of Shirakawa in northwestern Gifu prefecture is known for its spectacular farm houses. These imposing structures used to house as many as fifty or sixty family members. The steeply pitched thatched roof and the multistoried construction are typical of the rural architectural style known as *gassho-zukuri*, which is cool in the summer and warm in the winter. The extended family lived a socially determined existence and the patriarch's place of honor at the fireplace was sacrosanct. The rest of the family was assigned sitting spaces according to sex and rank. Shirakawa, together with the village of Gokayama, has been designated as a UNESCO World Heritage Site.

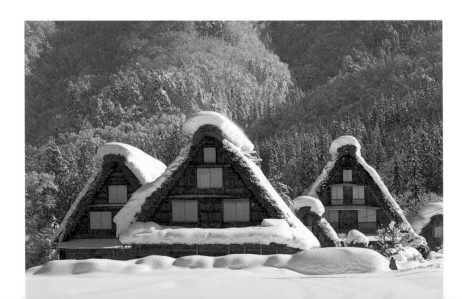

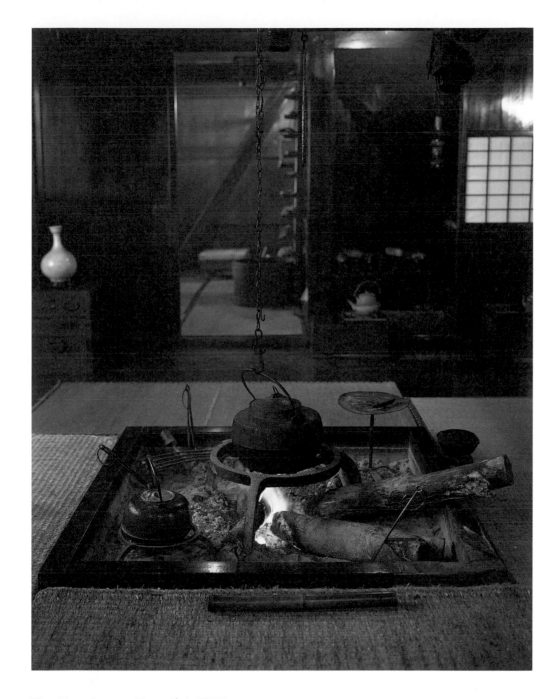

The Farmhouse Hearth | GIFU

The main room of this Shirakawa farm house was where the family gathered to eat. A tea kettle was suspended over the sunken fireplace where food was roasted or stewed, or simply kept warm by the flames. Here is a typical interior with a bamboo pipe (bottom of picture) through which air was blown to start and to maintain the fire.

Chubu Sake | NAGANO

Among the famous products of the Chubu region is sake, a brewed alcoholic beverage made from fermented rice. There are some 3,000 manufacturers in Japan, and much is made of their regional differences. Usually sake is served warm and drunk before and during a meal, but not after the rice is served.

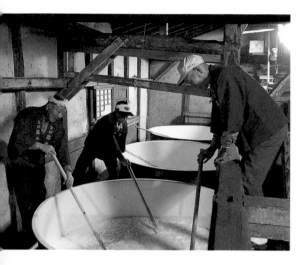

Nagoya Castle | AICHI

Nagoya, the major city of the Chubu region, boasts one of Japan's larger castles. It was originally finished in 1614 by Tokugawa Ieyasu but was badly damaged during World War II. In 1959 the main keep was rebuilt (seen here), and the remains—three corner turrets, three gate houses, and the stone foundation walls—are all designated Important Cultural Properties. Also reconstructed were the pair of golden dolphin-like decorations atop the main keep. From the top level, the Japanese Alps are plainly visible.

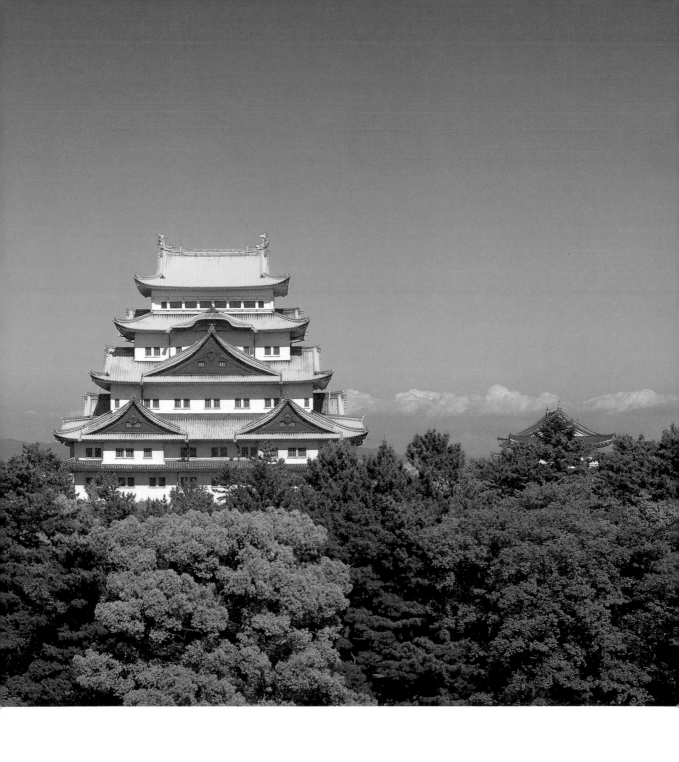

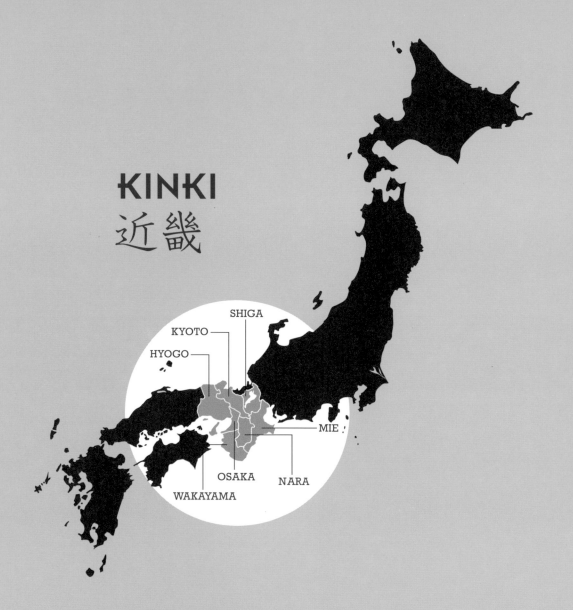

KINKI
近畿

SHIGA

KYOTO

HYOGO

MIE

OSAKA

NARA

WAKAYAMA

Often called the cradle of Japanese civilization, the Kinki region consists of Osaka, Hyogo, Kyoto, Shiga, Mie, Wakayama, and Nara prefectures. It was here, in the area known as Yamato, that the imperial clan first emerged, where the great capitals of Nara and Kyoto evolved, and where much of Japan's culture originated. As one commentator remarked, no other region has so much history packed into so little space. Dominated in the north by the Chugoku Mountains and in the south by the Kii Mountains, the Kinki region has an unlimited number of scenic sights.

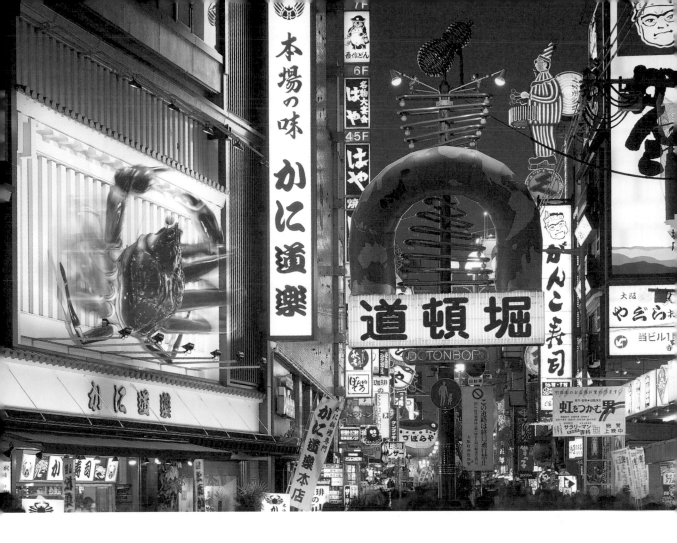

Dotonbori | OSAKA

Osaka, the largest Japanese city after Tokyo and Yokohama, is located on the site of Naniwakyo, Japan's first known capital. Having been partially destroyed during World War II, it is now a major economic center with a number of famous night towns, including the Dotonbori (above) with its bars and restaurants. Known for its sushi, its oysters, and its crab, Osaka cuisine is often advertised by one of the famous *kuidaore* ("Eat 'til you drop") figures (right), mechanical mannequins, the history of which extends far into Osaka's past.

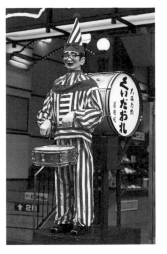

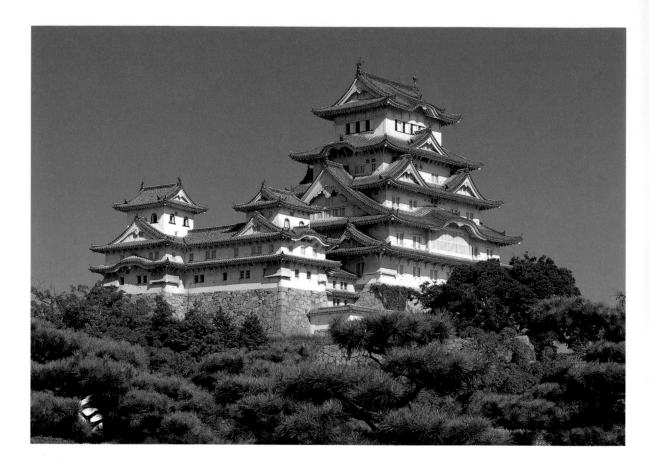

Himeji Castle | HYOGO

Osaka and Tokyo, as well as many smaller places, have castles, but none are as elaborate or as well preserved as that at Himeji. Known as the Shirasagi (White Egret) Castle because of a supposed resemblence to that tall, white bird, the castle was built in the mid-fourteenth century and reached its present form in 1618. The simple elegance of the layered gables and cusped windows and its labyrinthine walls have long been praised. Most of the original structures remain, and the castle has been designated a National Treasure and a UNESCO World Heritage Site.

Lake Biwa | SHIGA

A diametrical opposite of the crowded streets of Osaka are the often deserted shores of Lake Biwa near Kyoto. Japan's largest freshwater lake, it reaches a depth of 50 meters (164 ft), and along its shores are the so-called eight scenic spots of Omi. Despite recent industrialization, the waters still hold trout and carp, and freshwater pearl cultivation is carried out. And the migrating heron still finds a temporary home there.

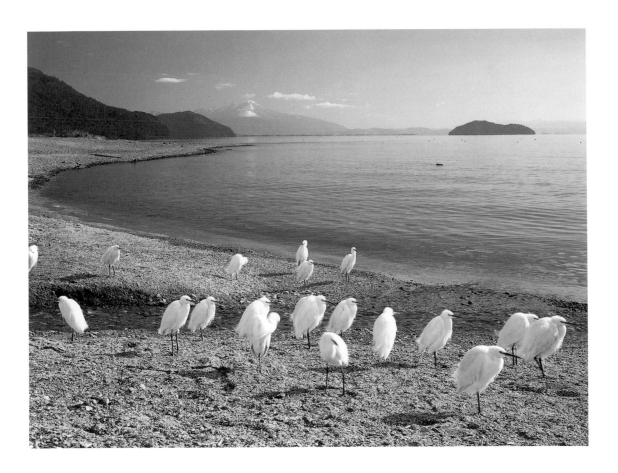

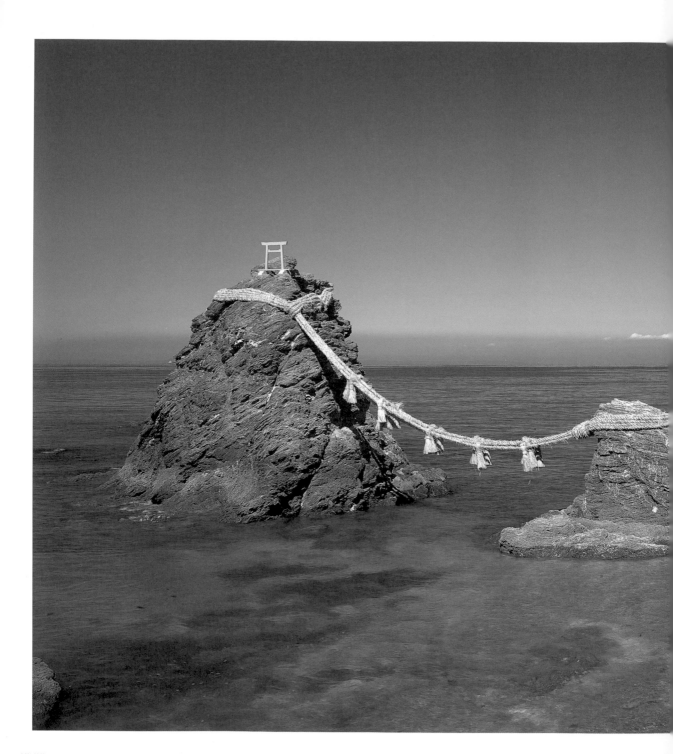

Kumano | WAKAYAMA

To the south, in mountainous and forested Wakayama prefecture, is the still mysterious district of Kumano. Here are the three shrines of Hongu, Haya-tama, and Nachi — some of Shinto's holiest sites. At the latter is found the Nachi Falls, exceptionally sacred and one of Japan's highest waterfalls. In the same prefecture is found the district of Yoshino, equally replete with ancient lore and home of the extraordinary cherry groves of Yoshinoyama. The entire district is now the Yoshino-Kumano National Park and contains some of the finest unspoiled scenery in Japan.

The Wedded Rocks | MIE

Futamigaura is a small resort town on Ise Bay famous for two rocks linked by *shimenawa* (sacred ropes). Called the Meotoiwa (The Wedded Rocks), they are likened to the two ancient dieties Izanagi and Izanami, as recounted in the eighth-century *Kojiki*. Once popular as a destination for honeymooners, the attached shrine, the Okitama Jinja, is replete with animal fertility symbols, including a reigning monkey divinity (Sarudahiko Okami) and numerous representations of frogs.

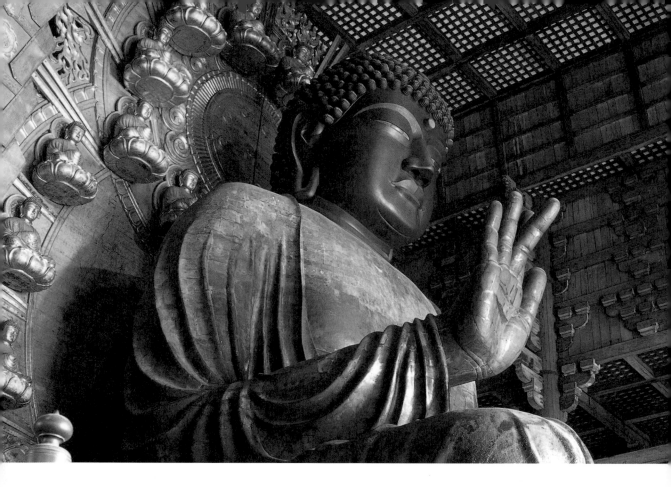

The Great Buddha of Todaiji | NARA

There are many things to see in the ancient capital of Nara — ancient temples and shrines, the deer park, and the Great Buddha of Todaiji. The colossal image of the Buddha was officially completed in 752 AD, when the temple of Todaiji was the very symbol of government-sponsored Buddhism. In the following years, Nara was largely destroyed and for a time abandoned when the capital moved to what is now Kyoto. In 1180 and in 1567 the temple itself burned down. Though heavily repaired, the Buddha still remains today in its enormous wooden hall, constructed in 1709.

KYOTO
京都

KYOTO

The old capital of Japan and the home of the imperial court from 794 to 1868, Kyoto contains the country's richest store of historical sites, relics, and structures—some twenty percent of the country's National Treasures. Located in Kyoto prefecture and the home of two million people, it is visited annually by an estimated forty million tourists. Originally modeled on an ancient Chinese capital, Kyoto is one of the few Japanese cities that conforms to a grid pattern. One result is long and beautiful vistas; another is that the visitor rarely gets lost.

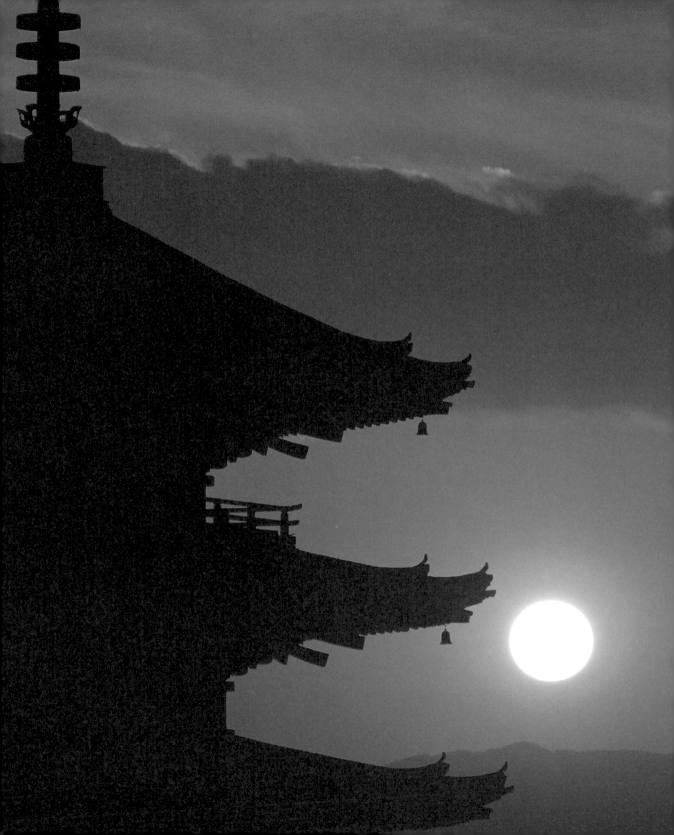

Yasaka Shrine

Yasaka Shrine in downtown Kyoto is located near the Gion geisha area and, indeed, is often called Gion Tenjin. Famed for its cherry blossoms, it is one of Kyoto's prettiest places of worship. Legend has it that the shrine was founded in 656. The central gate dates back to 1497, and the main hall to 1654. A much admired sight is mature geisha and the teenage *maiko* gathering under the cherry blossoms to pray at the shrine and to admire each other's kimonos.

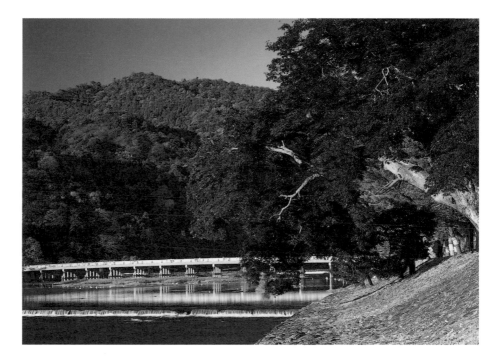

Arashiyama

Among the many popular sights outside central Kyoto is Arashiyama in the western section of the city. It is known for its cherry blossoms and autumn foliage, and for the views of the Hozugawa River and the Togetsu Bridge. All of these places are famous in classical literature, for the Arashiyama area has been a pleasure ground since earliest times. It was the Emperor Saga (reigned 809-823) who planted the cherry trees brought here from the famed groves of Yoshino.

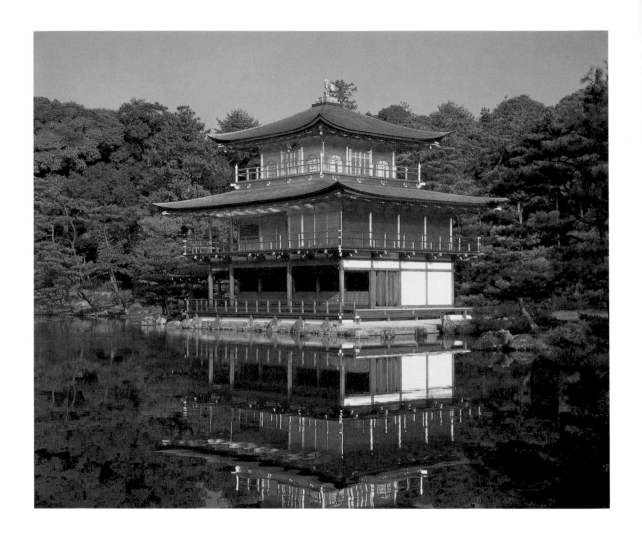

The Golden Pavilion

Among the many things to see in Kyoto, one of the most popular is the Golden Pavilion, or Kinkakuji. Originally intended as an elegant retreat for the shogun Ashikaga Yoshimitsu, it was begun in the late fourteenth century and converted into a temple after the shogun's death. A complex of ecclesiastical structures, the temple suffered frequent damage, and the Kinkakuji itself, the only building left from the shogun's time, was completely destroyed by arson in 1950. The reconstruction we now see was completed in 1955.

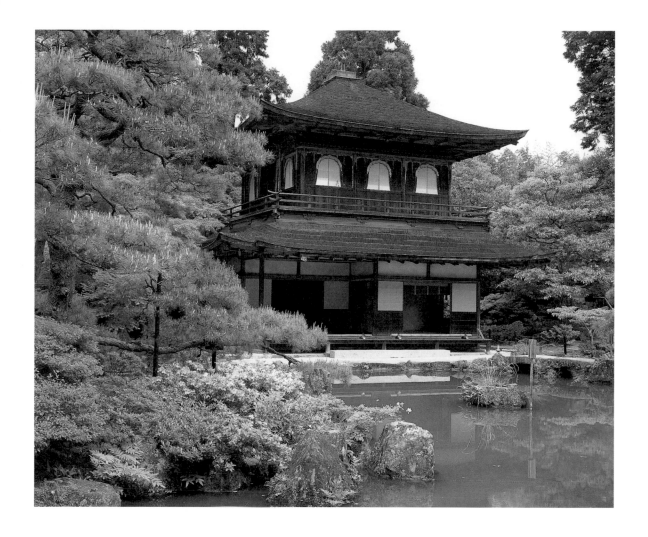

The Silver Pavilion

Commonly thought of as a counterpart to the Golden Pavilion, the Ginkakuji, or the Silver Pavilion, has a completely different history. Constructed by the shogun Ashikaga Yoshimasa in the late fifteenth century, it was early ordained a temple and named Jishoin. Conceived, like the Golden Pavilion, as one of a group of buildings, it was originally to be covered in silver leaf. Though the silver leafing was never completed, the structure is still famous as the Silver Pavilion and is considered the epitome of refinement and restraint.

Saga Bamboo

Memories of Kyoto always include the many stands of bamboo, such as this one in the Saga district of the city. This strong, flexible, tall grass (for that is what it is) is not only beautiful in its wild state, it is also nearly limitless in its many uses. Not only does it make blinds and fences, hairpins and combs, it is also used for vases and flower baskets, for *shakuhachi* flutes and bird and insect cages. Umbrellas, rakes, buckets, fans, brooms, and boxes are all made of bamboo. It is one of the "three felicitous plants," the others being the plum and the pine.

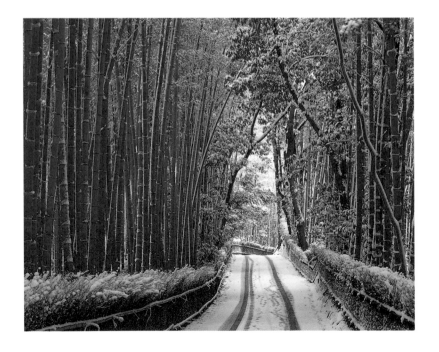

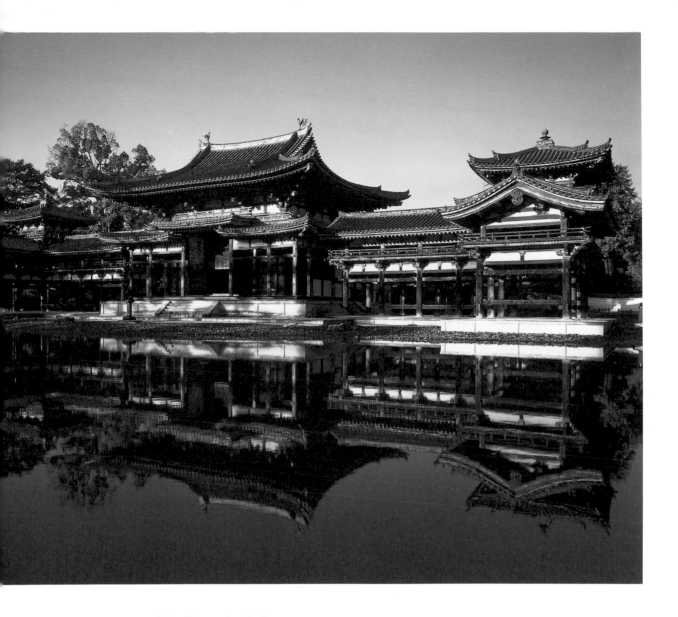

The Phoenix Hall

Earlier than either the Golden or Silver pavilions, the Phoenix Hall (Hoodo) is one of the finest architectural examples of its period. It was originally part of a large complex of buildings known as the Byodoin Temple. Completed in 1053, it has been repaired many times but still retains its architectural integrity. The main hall is flanked by two galleries, the whole suggesting the mythic phoenix spreading its wings in full flight. Though still considered a temple, it no longer serves in the performance of regular Buddhist ceremonies, but is regarded—as indeed it always has been—as a singularly beautiful building, a mirror of the Buddha Amida's heavenly palace.

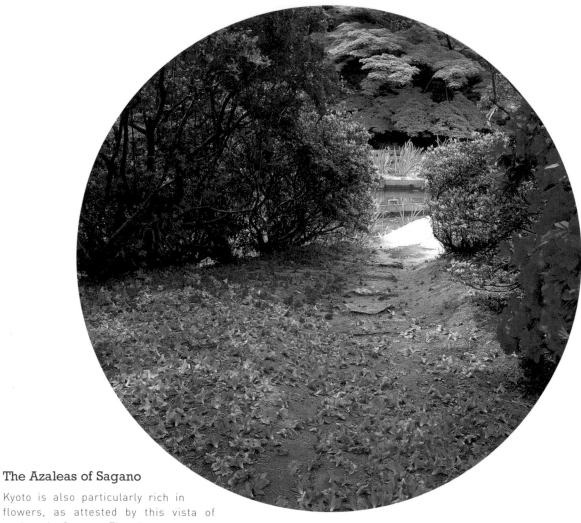

The Azaleas of Sagano

Kyoto is also particularly rich in
flowers, as attested by this vista of
azaleas in Sagano. The cherry blossoms are
yearly admired by throngs of people, with outings
scheduled according to their appearance, complete with
picnic meals and a good deal of sake. The cherry is shortly
followed by the azalea, with many famous spots where they can be
seen. Shortly after their peak comes the Japanese iris, and so on around
the circle of the seasons, until fall brings the brilliance of the turning leaves
and an end to the cycle.

The Kibune River

Not only beautiful flowers but pristine greenery itself is much admired. Here,
a dining pavilion is suspended over the Kibune River, snugly resting
under the maple trees that line the river's banks. Likewise a
grove of bamboo or a stand of pine is often remarked upon
for its own sake. Though Japanese poetry has its share
of flowers and blossoms (particularly cherry
blossoms), it also celebrates the plain and
perfect green of a field or a forest, and
many are the haiku which celebrate
natural simplicity.

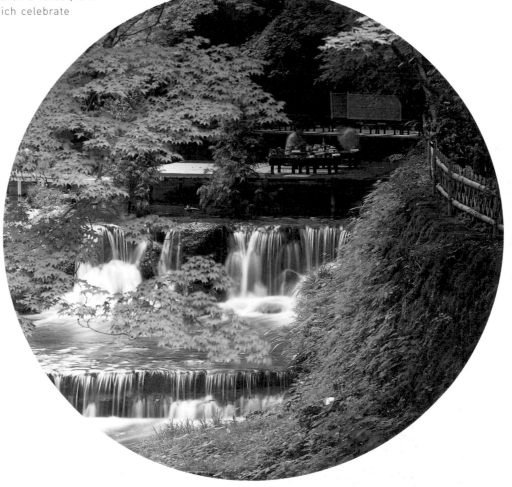

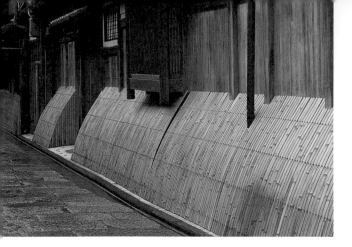

The Streets of Gion

Traditional Japanese architecture often reflects the simplicity admired in nature. The streets of the Gion in Kyoto, home of the geisha houses, reflect this aesthetic. The craftsmanship is evident in the simple use of plain materials, as in this *inuyarai* ("dog fender," above), an elegant bamboo sheathing found now mainly in Kyoto, the purpose of which is to encourage cleanliness and fend off (as the name indicates) the attentions of stray animals.

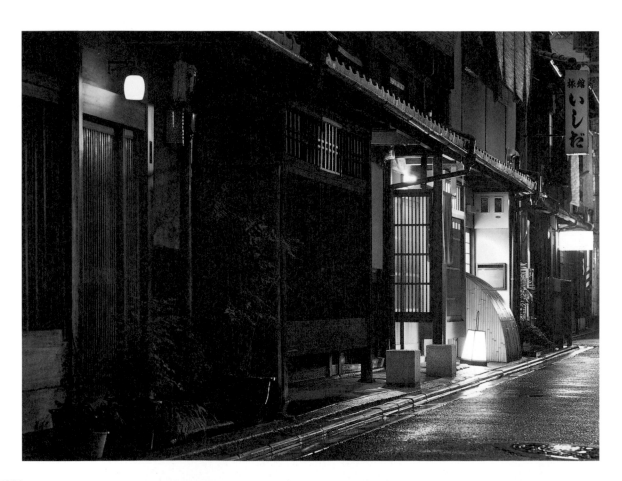

Geisha and Maiko

The Gion is one of the few places in Japan where geisha and the apprentice *maiko* can be seen as they stroll to their evening engagements. Traditionally, the girls and women were entertainers, and in prewar Japan no party with any pretensions was complete without their presence. Now, though much reduced in number and, as always, very expensive, they still provide that conviviality which all male gatherings seem to need.

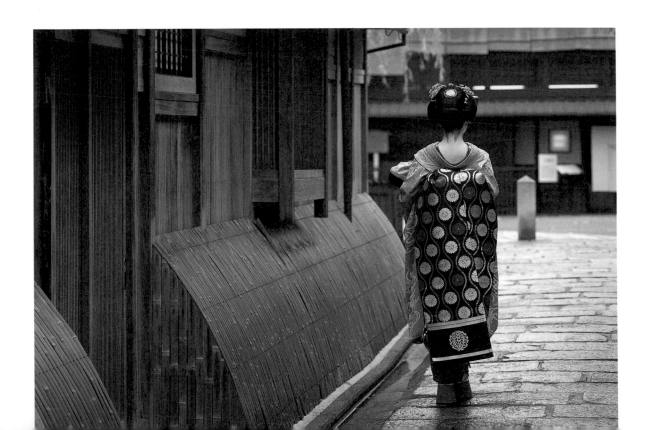

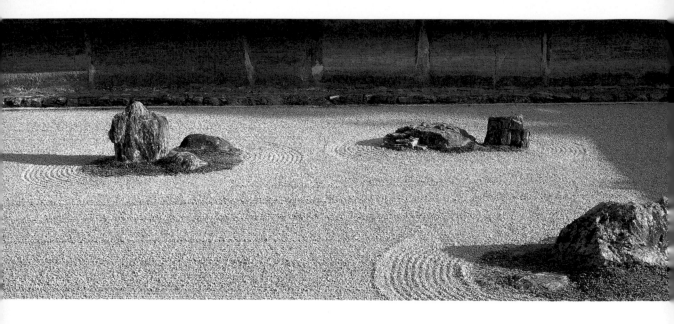

The Stone Garden of Ryoanji

Of all the many gardens of Kyoto, the stone garden at Ryoanji Temple has long excited the most interest. In the *karesansui* ("dry landscape") style, it features no greenery at all. Consisting of fifteen oddly shaped rocks placed on a bed of white sand which is freshly raked daily, it has been often illustrated and explained as islands in the sea, a mother tiger and her cubs, a map of the infinite, etc. Laid out in the early sixteenth century, it remains in its way an ideal garden in that it can be anything to anyone.

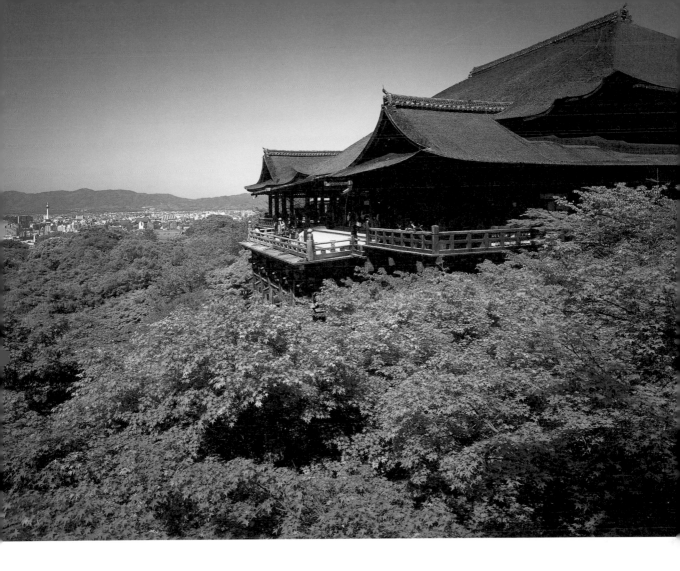

Kiyomizudera

Kiyomizudera is one of the more spectacular sites of Kyoto because its great veranda affords a striking view of the valley below and city beyond. Though the original temple dates from the eighth century, the present temple building and its veranda are of later making, the last complete reconstruction being in 1633. The supports for the veranda consist entirely of joinery with no nails used. Their simplicity and completely utilitarian appearance add much to the temple's beauty.

Traditional Shops of Kyoto

The domestic architecture of old Kyoto, though now much less in evidence than it once was, still reflects a standard of utilitarian elegance that reminds modern Japan of what is being lost. Above is an *obi* (kimono sash) shop in the old district of Nishijin near the Gion. Below is the warehouse of a sake-maker in Fushimi, south of the city. Both are constructed with the simplicity that is the hallmark of good design, with lines balancing and forming parallels in what constitutes a national aesthetic.

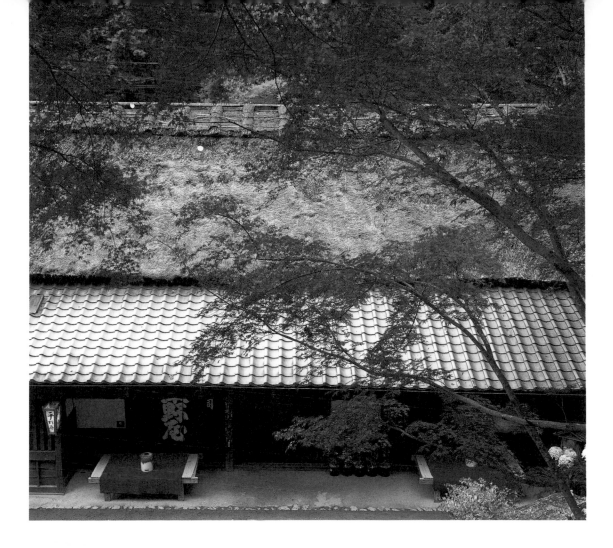

Sagano Foliage

How well traditional Japanese architecture blends into nature is seen in this view of the restaurant Hiranoya at Sagano, Kyoto. Its wide tile roof is topped by rustic thatch, and the whole is set off by the autumn brilliance of red maple trees and potted chrysanthemums, the flower of autumn.

CHUGOKU
中国

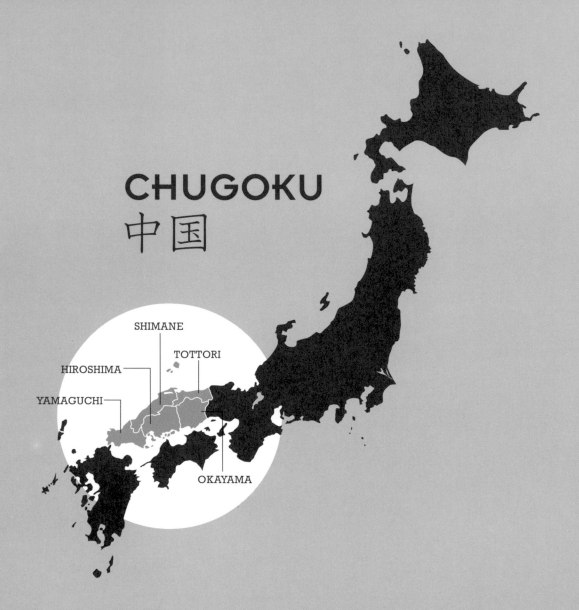

The western part of the mainland of Honshu constitutes the region known as Chugoku. It contains the industrialized San'yo coast on the Pacific Ocean side and the still largely rural San'in coast facing the Japan Sea. Between Chugoku and the island of Shikoku lies the lovely Inland Sea, leading down to the southern island of Kyushu. It is along this corridor that swept the tide of cultural influences from China and the Asian continent.

Peace Park | HIROSHIMA

The single fact known by everyone about Hiroshima is that on August 6, 1945, at 8:15 AM, the United States launched the first atomic bomb attack. The explosion point was almost directly over the Industrial Promotion Hall. Its ruins are standing to this day in demonstration of the force and inhumanity of the bomb. Nearby is the Peace Park (Heiwa Kinen Koen) and the sobering Peace Memorial Museum (Heiwa Kinen Shiryokan). The destruction of the city was so overwhelming that these sites preserve the few architectural survivors of the ferocity of the bomb.

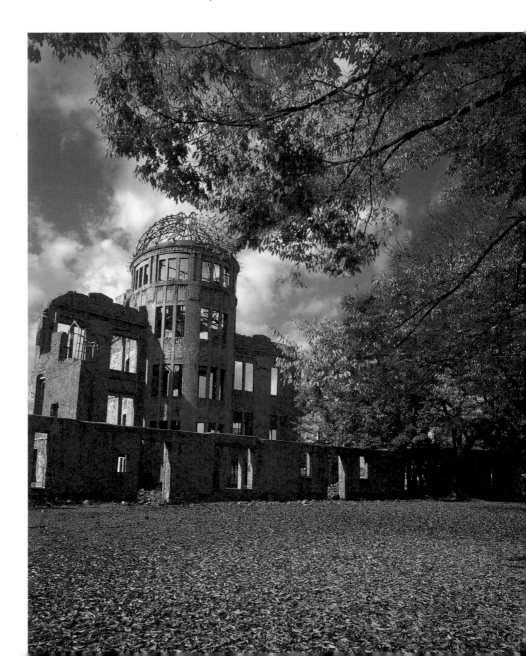

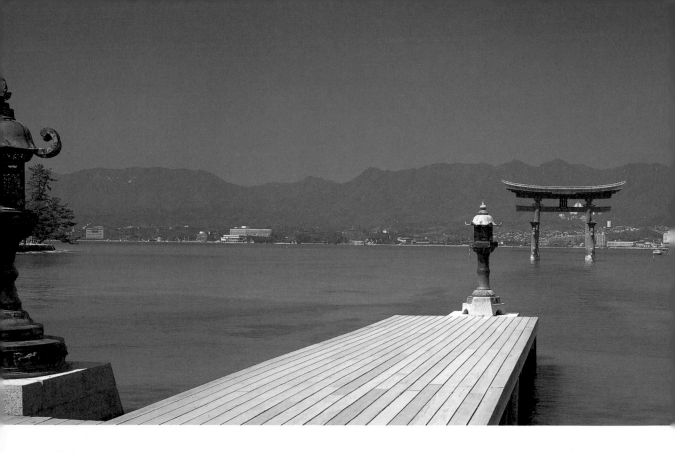

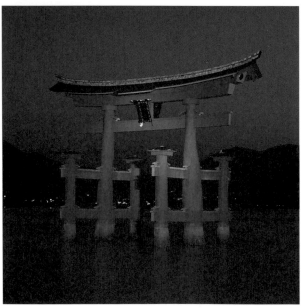

Miyajima | HIROSHIMA

Just a short ferry ride from the suburbs of Hiroshima lies Miyajima (or Itsukushima) Island, ranking as one of three most beautiful sights in Japan — along with Matsushima near Sendai and Amanohashidate on the Japan Sea coast. The main attraction here is the bright red Itsukushima Shrine, holy ground since 593 AD, with its great scarlet *torii* gateway standing in the sea, the largest such gateway in Japan and surely one of the most beautiful. The shrine itself extends into the sea, and high tide accentuates its fancied resemblance to the fabled undersea palace of the Dragon King.

Onomichi | HIROSHIMA

Above Hiroshima and on the Inland Sea lies the old commercial port town of Onomichi. Since the twelfth century it has been a major center of marine commerce, with shipbuilding as its main industry. It is also the site of the temple Jodoji, now a National Treasure. Ono-michi is now a modern city and has considerably changed. It is the starting point of the Nishiseto Expressway, one of the three routes, consisting of numerous bridges, which now connect Honshu with Shikoku.

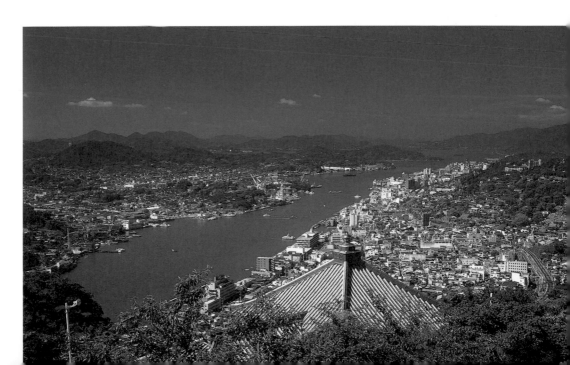

Tsuwano | SHIMANE

On the Japan Sea side of Chugoku lies the old castle town of Tsuwano, long known for its cultivation of ornamental carp. These fish come in a variety of colors and can measure up to one meter (three ft) in length. Beneath the black-tiled walls that once enclosed samurai estates are shallow canals filled with swarming carp. In the environs are the remains of the castle and the Yorokan, a school for samurai youth, as well as a memorial to Mori Ogai, the famous Japanese writer who was born here.

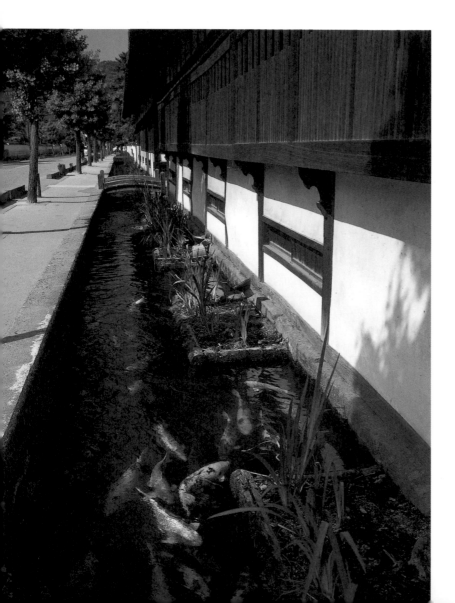

The Dunes of Tottori | TOTTORI

The Chugoku region is famous for the variety of its scenery. Above are the sand dunes of Tottori on the Japan Sea coast. This 2 kilometer-wide (1.2 mi), 16 kilometer-long (10 mi) expanse of desert is unique in Japan.

Akiyoshidai | YAMAGUCHI

Akiyoshidai, just down the coast, is a rolling grassland pierced by numbers of limestone up-thrustings. Also found here, under this rocky blanket, is one of the largest limestone caves in the world, the Akiyoshi-do, which extends for over 10 kilometers (6.1 mi) and holds whole rivers, waterfalls, deep pools, and numerous stalactites and stalagmites.

The Kammon Bridge | YAMAGUCHI

Connecting the islands of Honshu and Kyushu is the Kammon Bridge, which spans the Kammon Strait, part of which is the famous Dannoura inlet. It was here that on April 25, 1185, the Minamoto (or Genji) forces defeated the Taira (or Heike) clan in the concluding battle of Japan's most famous civil war. It was a naval battle in which hundreds were killed and which has lived on in epic verse, song, and even in the movies. The bridge has not only facilitated automobile traffic but strengthened Japan's railway network by providing access for the Shinkansen bullet train into Kyushu.

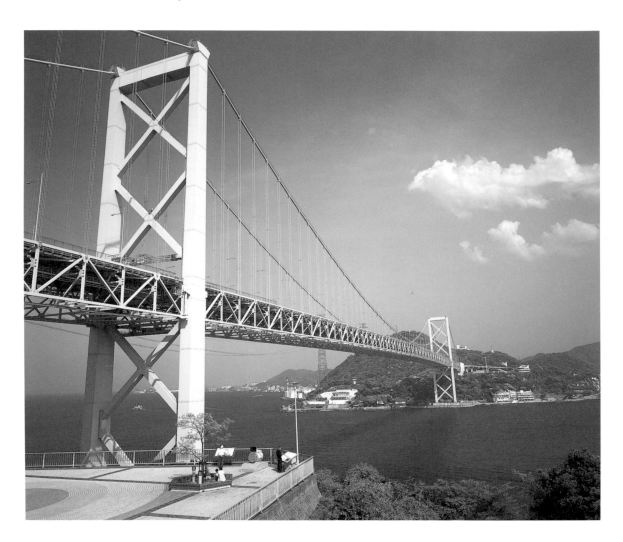

SHIKOKU
四国

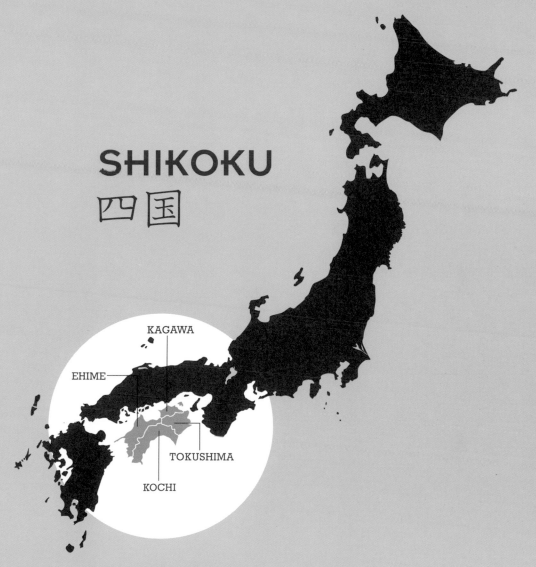

KAGAWA

EHIME

TOKUSHIMA

KOCHI

The smallest of Japan's four main islands, Shikoku was once noted only as having the most limited resources, but now it is famed as containing some of the best of unspoiled Japan. It consists of Kagawa, Tokushima, Ehime, and Kochi prefectures. The two main cities, Takamatsu and Matsuyama, are quite modern, but the island still offers forests, mountain gorges, and temples and shrines such as the towering Kompira-san, with 700 stone steps leading up to the main hall. There is Yashima, site of many Minamoto (Genji)-Heike (Taira) battles, the Ritsurin Garden in Takamatsu, and the famous pilgrim route around the 88 temples relating to Kobo Daishi, the famous priest who lived during the eighth and ninth centuries.

The Naruto Whirlpool | TOKUSHIMA

One of the most famous sights of Shikoku is not on the island itself but in the strait between Shikoku and Awaji Island. Here lies a whole system of cross currents which have become known as the Naruto Whirlpool. Created by rapid tidal currents and the resulting differences in water level, the currents develop considerable speed and are traditionally pictured as upending boats. In fact, big boats now safely pass through the area, and there is a bridge built directly over the strait.

The Shimanto River | KOCHI

The Shimanto River in southwestern Kochi Prefecture is the second largest river in Shikoku. Stretching for 196 kilometers (122 mi), it flows from the upper reaches of the Shikoku Mountains, where the mushrooms are famous, and empties into Tosa Bay. During its course, it is also home to the delicious *ayu* (sweetfish), a regional speciality. Unlike many a Shikoku river, its hydroelectric potential remains happily undeveloped. Now most of the rivers of Japan are interrupted by dams.

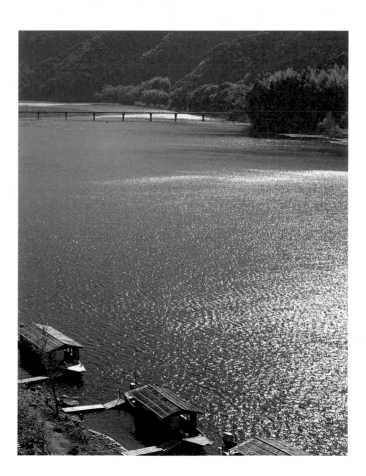

Rope Bridge | TOKUSHIMA

South of Tokushima City at the eastern end of Shikoku there once stretched miles of forests, and there are many rustic reminders today, including this *kazura-bashi* vine bridge. Tokushima is also known for its fine puppet tradition, its castle ruins, and because it is the home to one of Japan's largest and most lively festivals. This is the Awa Matsuri, held yearly in the middle of August, when the celebrants dress in traditional costume and dance in the city streets throughout much of the night .

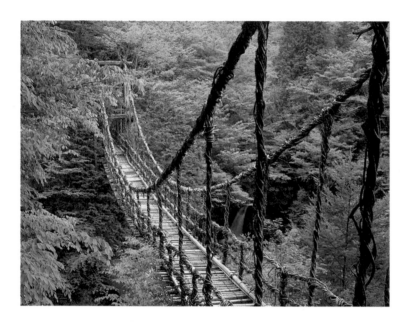

Cape Ashizuri | KOCHI

The cape of Ashizuri marks the southernmost point of the island of Shikoku. It is the focus of the Ashizuri-Uwakai National Park, the only national park wholly within the island. (The larger Setonaikai National Park spans both Honshu and Shikoku.) It is noted for its steep granite cliffs, its irregular bays, and small islets. The vegetation is sub-tropical, and the sea swarms with bonito fish. On the promontory is a small temple, Kongofukuji, supposed to have been built by the priest Kukai in 822, and the narrow roads to the lighthouse seem to justify the name of *ashizuri*, which means "leg grazing."

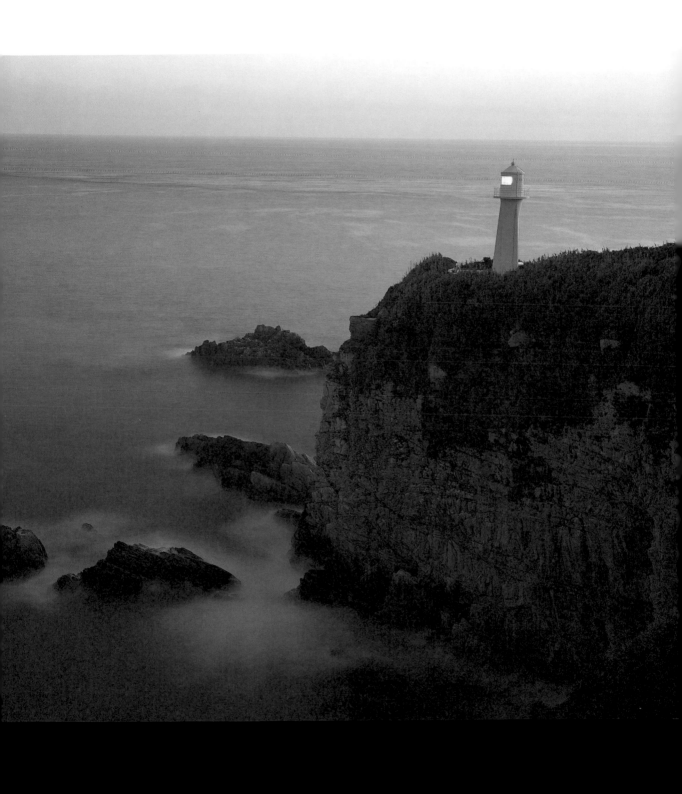

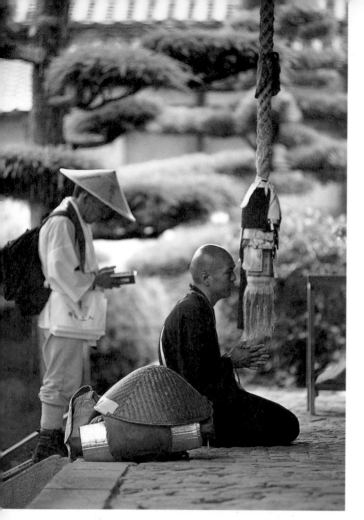

The Shikoku Pilgrimage | TOKUSHIMA

The priest Kukai (774-835), posthumously known as Kobo Daishi, is Shikoku's most venerated saint and the one most associated with the famous pilgrimage to 88 temples, the high point of which is a visit to Zentsuji, his birthplace. Here the pilgrims (left) pray and then move on to the next temple, assisted by their walking sticks (below), which are stamped and otherwise decorated at each stop and later dedicated to the final temple. This difficult pilgrimage is still popular, and the summer tourist usually catches sight of a good number of white-clad pilgrims.

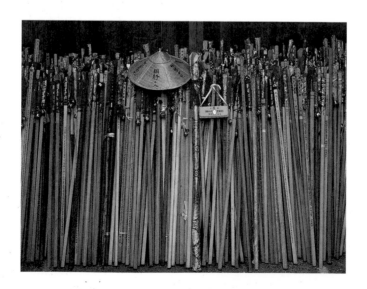

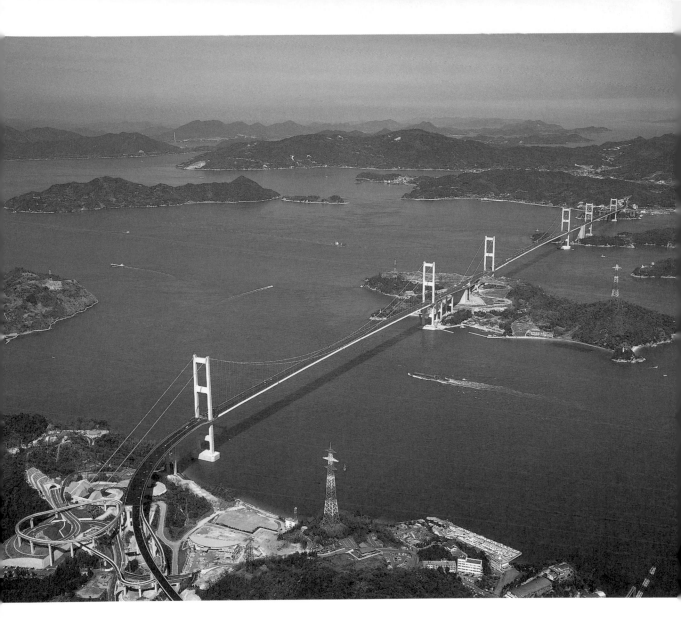

The Shimanami Sea Route | HIROSHIMA-EHIME

The Shimanami Sea Route, or Shimanami Kaido, is one of the three systems of bridges that connect Honshu with Shikoku. Completed in 1999, it consists of ten bridges spanning six islands in the Inland Sea. Its starting point on Honshu is Onomichi City, Hiroshima Prefecture, and its touchdown point in Shikoku is Imabari City, Ehime Prefecture. Its total length is 59.4 kilometers [36.9 mi]. The other two bridge systems consist of three and six bridges and cover distances of 9.4 kilometers [5.8 mi] and 89 kilometers [55.3 mi], respectively.

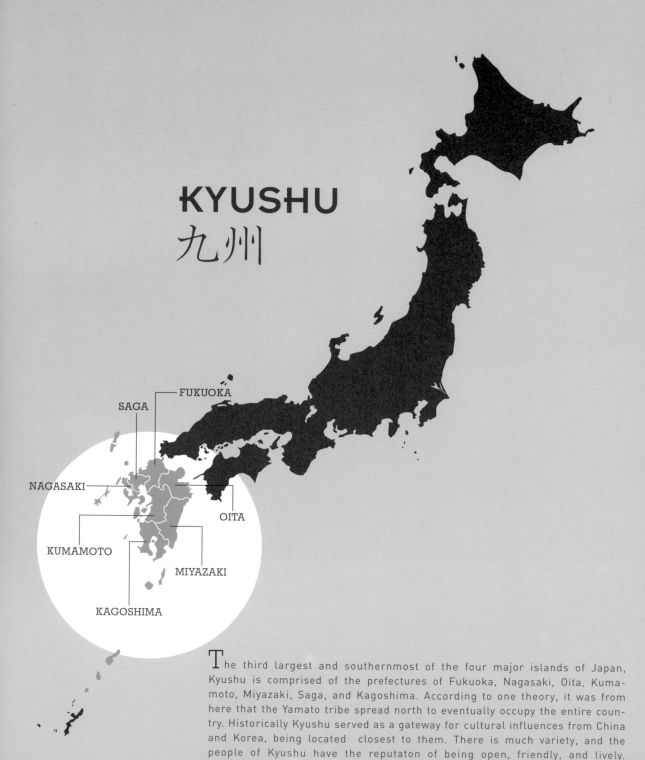

KYUSHU
九州

FUKUOKA

SAGA

NAGASAKI

OITA

KUMAMOTO

MIYAZAKI

KAGOSHIMA

The third largest and southernmost of the four major islands of Japan, Kyushu is comprised of the prefectures of Fukuoka, Nagasaki, Oita, Kumamoto, Miyazaki, Saga, and Kagoshima. According to one theory, it was from here that the Yamato tribe spread north to eventually occupy the entire country. Historically Kyushu served as a gateway for cultural influences from China and Korea, being located closest to them. There is much variety, and the people of Kyushu have the reputaton of being open, friendly, and lively.

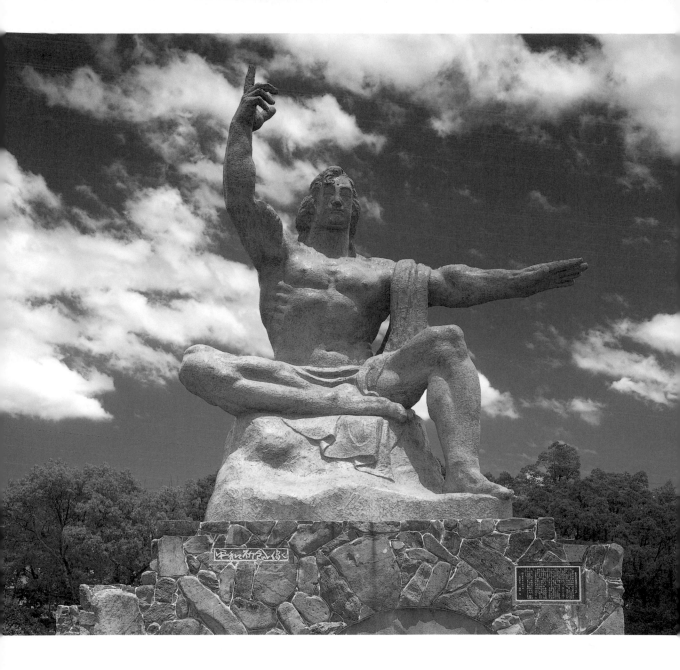

The Nagasaki Peace Park | NAGASAKI

Nagasaki, Kyushu's largest port, is known for a number of things. It has had a long association with foreign countries and it was, indeed, for some time the only place foreigners were allowed to settle — on the harbor island of Dejima. It was among the first free, international ports. And it was here, ironically, that the Americans made their second atom bomb strike at 11:02 AM on August 9, 1945. Ten years later the Statue of Peace (above), cast by Seibo Kitamura, was erected in the Nagasaki Peace Park.

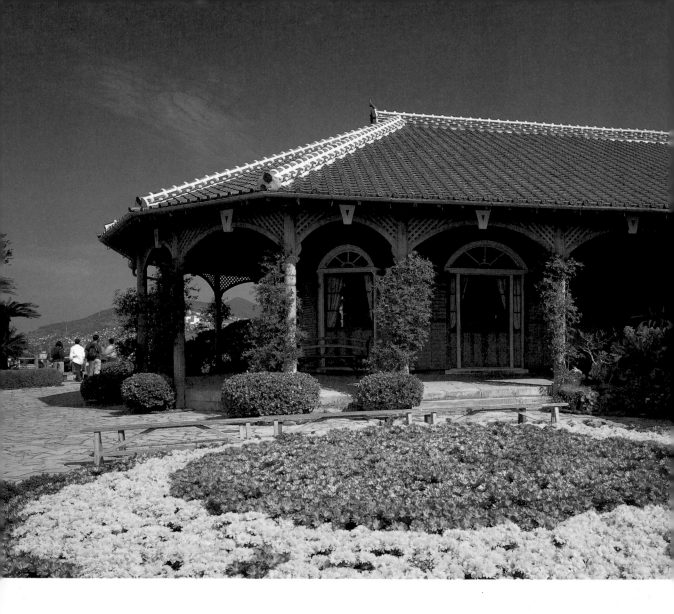

Nagasaki Foreign Homes | NAGASAKI

Home to the first foreign residents, Nagasaki still contains their often opulent residences, now gathered into a conclave in the hills above the harbor. Above is the Thomas Blake Glover home with its celebrated floral displays. Glover was a Scotsman who provided arms to the winning side in the so-called Meiji Restoration. He built the first Japanese railway, and he married a local woman who is said to be the original of the Madame Butterfly legend. There is a statue of her just outside the grounds.

Dazaifu Shrine | FUKUOKA

The city of Dazaifu has been important in Japanese history from early times as an administrative center, a center for trade with China and Korea, and a stronghold against Mongol invasions. Far from the center of power on Honshu, Dazaifu also became a place of exile. One such exile was the scholar and statesman Sugawara no Michizane, who died there in 903 AD. Dazaifu Shrine, dedicated to the slandered official, was built in 919 to appease his vengeful spirit. The present main building dates from 1591.

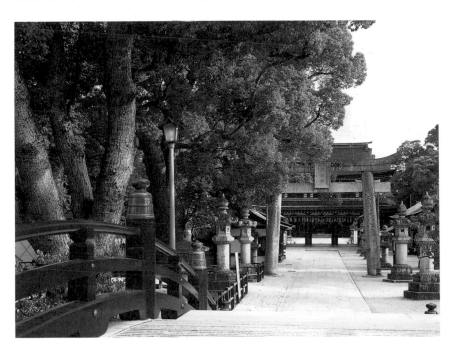

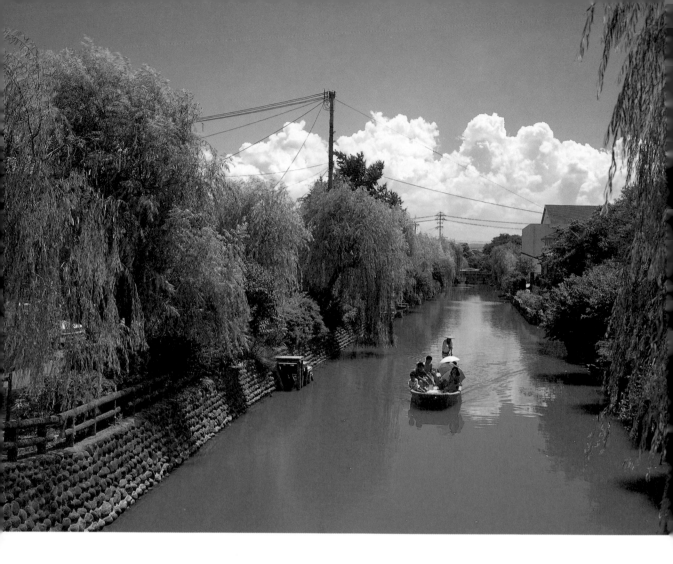

Yanagawa | FUKUOKA

In central Kyushu, not far from Kurume, the city of Yanagawa is located at the mouth of the Chikugo River. It features a network of creeks and canals of an earlier time. Here one may boat past old houses, lanes of willow, fields of wild flowers. There are beautiful old warehouses and ample old-fashioned inns. Here is where the poet Kitahara Hakushu (1885-1942) was born and sang the praises of a time when man and nature lived in accord. The boat trip through history takes only an hour or so, but the vision of the past lingers longer.

Arita | SAGA

Kyushu is famous for its kilns and various kinds of pottery. Located in western Saga prefecture, the town of Arita was first introduced to fine porcelain by the Korean artist Yi Sam-p'young in 1616, his process later perfected by the Japanese Sakaida Kakiemon (1596-1666). In the town itself, the kiln bricks are reused as building material. Here are ceramic *tonbai* walls which guard the potters' houses and workshops.

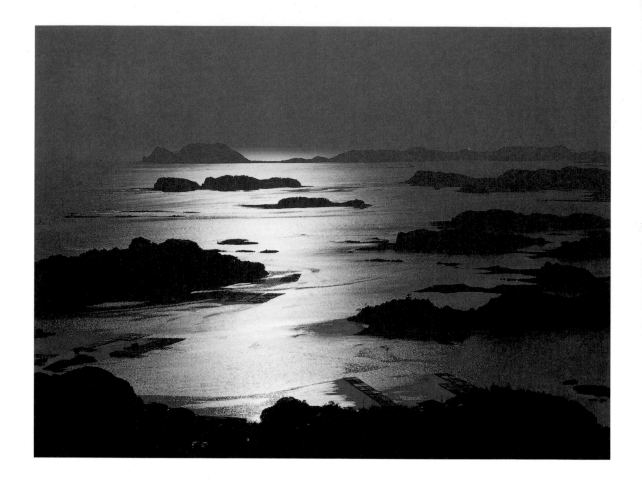

Kujukushima | NAGASAKI

Off the coast of Nagasaki prefecture is the island group of Kujukushima (Ninety-nine Islands), though there are over 200 of them. It is a place of still largely unspoiled beauty and is filled with much historical interest. It was in these islands, and those of the Goto chain, that the first Christian missionary contacts took place. There are also reminders of other early visitors: the *wako* pirates who forced the coastal population to move inland to avoid their depredations, and who consequently opened up the interior of these islands to settlement and commerce.

Hamano-Ura | SAGA

Another part of rural Kyushu is Hamano-Ura, the main product of which is rice. Here the terraced paddies lie next to the sea itself and help swell the annual rice harvest, Japan's principal crop. Early beginning rice cultivation, the Japanese have long made this cereal their staple diet. Though there has been some decline in production in recent years due to changing diets and lack of space for large rice paddies, the rate of production is still many times that of corn production in the United States.

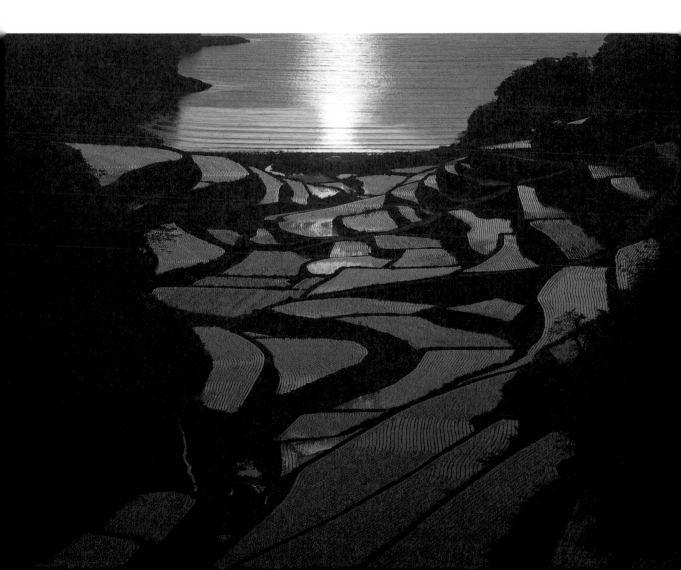

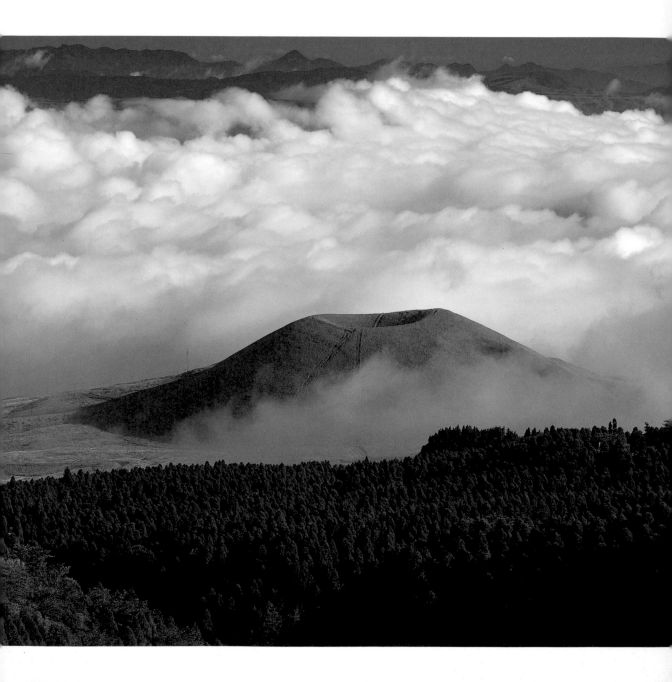

Mount Aso | KUMAMOTO

In central Kyushu we find the largest active volcano in Japan, Mount Aso. It consists of a number of peaks and cones and has one of the world's largest calderas, with a circumference of 80 kilometers (50 mi). This caldera was created over 90,000 years ago, and is now the home of seven towns and villages. Of the so-called Five Peaks of Mount Aso, Mount Naka is the one still active. While bleakness rules in many areas of the volcano, it is surrounded by forests and fields of great beauty. At left we see the lovely, inactive cone known as Komezuka.

Beppu | OITA

Since Kyushu remains the most volcanic of the islands of the Japanese archipelago, it is not surprising that it also has a great variety of hot springs (*onsen*). There are approximately 3,000 natural hot springs in Beppu alone, including a diversity of waters. There are still pools, sulphur lakes, and the famous Jigoku-dani (Hell Valley), complete with geysers. In the cool evening the sky of Beppu is filled with clouds of steam from the waters below.

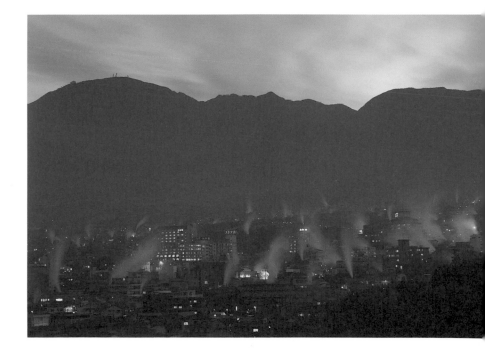

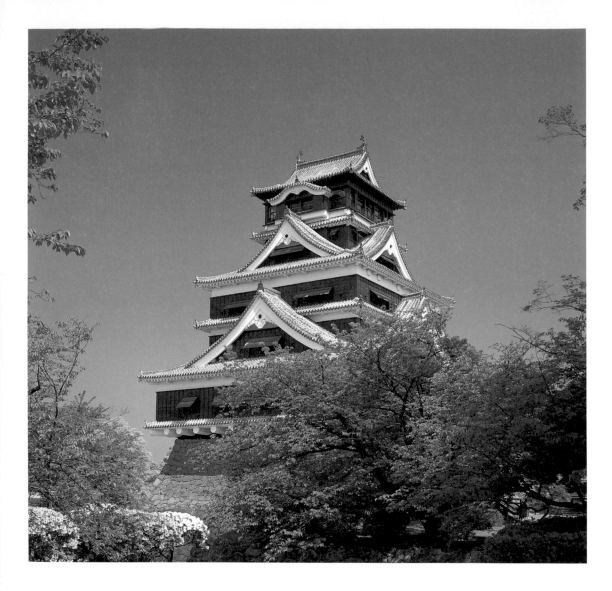

Kumamoto Castle | KUMAMOTO

Here, among the flowering azalea, is the castle of Kumamoto. It is still a major tourist sight despite its main keep having been destroyed during the Satsuma Rebellion of 1877, now reconstructed in concrete but looking much as it once did. Eleven of the original turrets survive, and the castle keep now houses a museum. Kumamoto also boasts one of the best stroll-type landscape gardens, Suizenji Park. Dating from the mid-seventeenth century, it is older than many of the more famous ones and in some ways more beautiful.

Sakurajima | KAGOSHIMA

At the southern tip of Kyushu lies the city of Kagoshima, and in its bay looms the active volcano of Sakurajima. The combination of city, bay, and smoking volcano has earned Kagoshima the title of "Naples of the Orient." Unlike Vesuvius, however, the south peak of Sakurajima erupts almost daily, often smoking and sometimes covering the town below with showers of ash. Until 1914 the mountain was an island, but in that year an eruption connected it by a lava bridge to Osumi Peninsula.

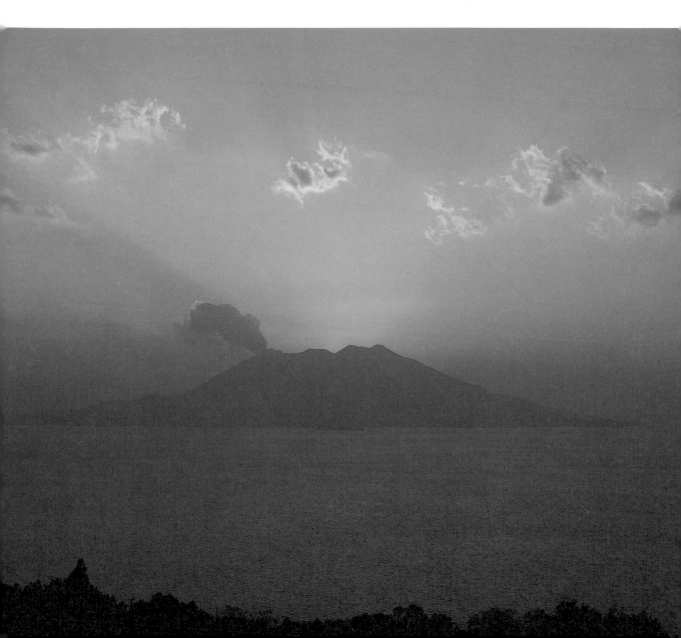

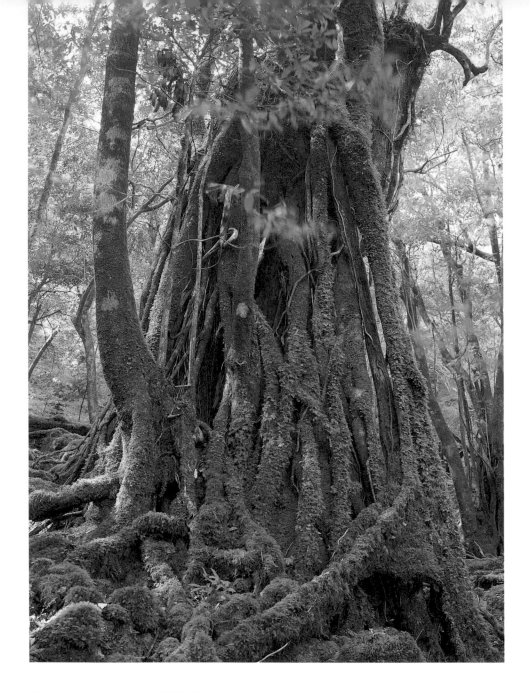

Yakushima | KAGOSHIMA

The island of Yakushima, to the south of Kagoshima, contains the highest peak in the Kyushu region. It also has the heaviest precipitation in Japan — 10,000 millimeters (394 in) average in the mountainous forests covering most of the island. This abundance of rain perhaps explains the proliferation of the Japanese cryptomeria (*yakusugi*), which grow to an enormous height. One of their number has recently been declared the equivalent of a National Treasure.

OKINAWA
沖縄

OKINAWA

Far to the south of mainland Japan, the Okinawa archipelago, consisting of 49 inhabited and innumerable uninhabited islands, has a long and varied history. Originally an independent nation and known as the Ryukyu Kingdom, it was annexed to Japan in 1879. After World War II Okinawa fell under the control of the US military. Only in 1972 did it become again one of the prefectures of Japan, though still hosting a number of American military bases. Okinawa features tropical weather, good rainfall, a wealth of food products, and an ambience that mainland Japanese find exotically attractive.

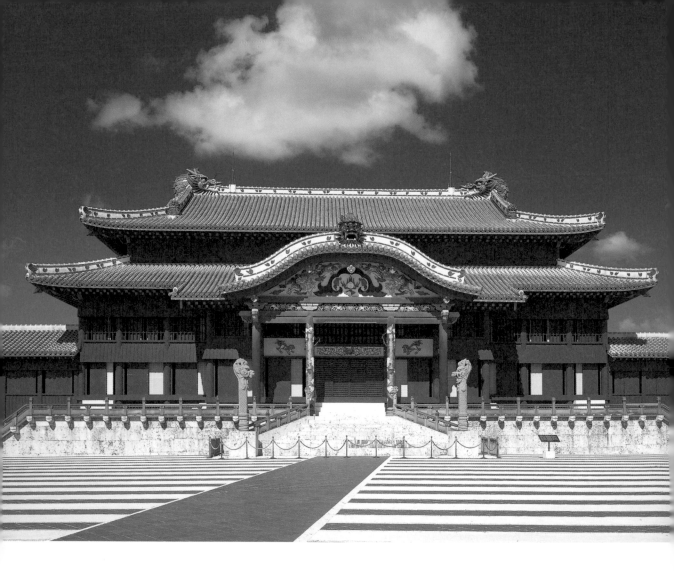

Shuri Castle

The recently completed Shuri Castle is a detailed reconstruction of the complex built during the early fifteenth century and destroyed by American bombardment during the Pacific War. Here we see the main hall. There is a strong Chinese aesthetic influence, and this is seen in the castle's structure and ornamentation. This influence can also be seen in Okinawan textiles. Made of bast fibers as well as cotton and silk, the native textile designs are largely geometric.

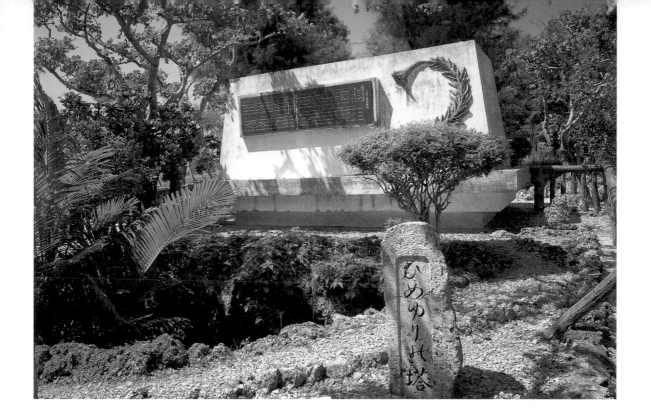

The Himeyuri Monument

Toward the end of World War II, a corp of high school students and their teachers were recruited to work in field hospitals. The name of the corp, consisting of over 200 girls, was taken from their school newspapers: *Hime* (maiden) and *Yuri* (lily). Three months later, the corp found itself working in hospitals located in caves. As the war drew to an end, the nurses were told that their services were no longer needed. However, with fighting raging everywhere, the majority of them were killed in the caves, committed suicide, or lost their lives in trying to escape. The small monument to the Himeyuri Corp seen above was erected immediately after the war; the larger and newer one in the rear gives all the names of those who perished. Below the larger monument can be seen the entrance to one of the caves.

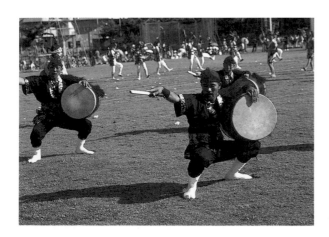

Okinawan Dance

Here we see some of the drummers and dancers who make up Okinawa's continuing cultural renaissance. The music and dance of Okinawa are as distinctive as its scenery and perfectly reflect the life of these southern island people.

Oganzaki

Located on the western coast of Ishigaki Island, Oganzaki is known for its precipitous cliffs, its rocky inlets, and the extent and variety of its coral reefs. There is a white lighthouse to keep errant ships away, and the point is famous for the beauty of its sunsets. Although perhaps an ideal site for development and tourism, its location and difficulty of access have so far spared it.

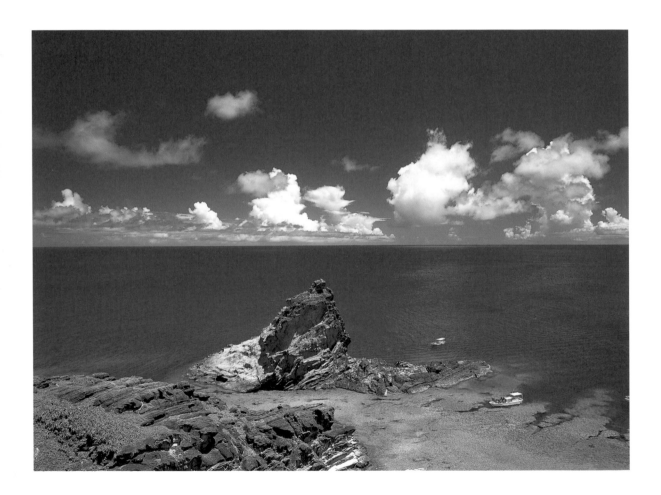

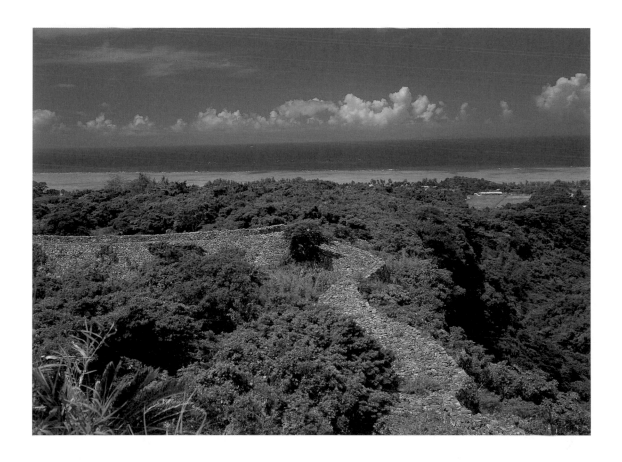

Nakijin

The scenery of Okinawa is quite different from that of the rest of Japan. The sea is turquoise or indigo or even cobalt blue, the forests are a verdant yellow-green, and the gray of the rocks stands in monochrome contrast. This is evident at Nakijin Castle on the Motobu Peninsula in the north of Honto, the main Okinawa island. Here the gray stone belongs to the ruins of the great castle, built in the fourteenth century by the king of one of the competing principalities of the time. The jungle has not yet claimed the castle's massive walls.

The Nakamura Residence

The complex of buildings known as the Nakamura Residence is said to have been built in the mid-eighteenth century for a village headman. While it carries on the tradition of Japanese architecture of the Kamakura (1185-1333) and Muromachi (1338-1573) periods, it has many special features that are characteristic of Okinawan architecture. The south side is open to the sun, while the east, north, and west are surrounded by limestone walls. Inside the walls is a growth of *fukugi* trees to act as a windbreak against typhoons. Pictured here is the backside of the storehouse.

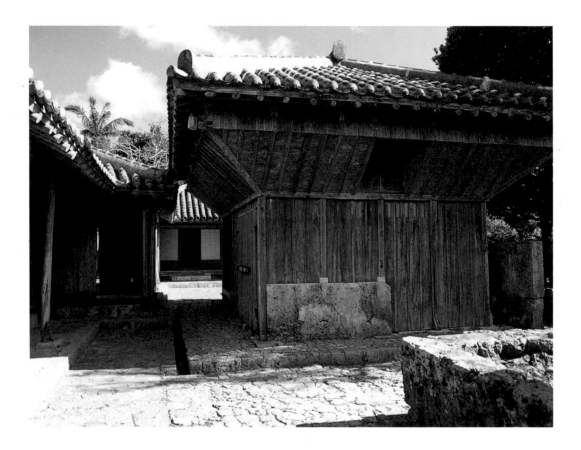

Traditional Yaeyama

At the southernmost tip of the Okinawan islands are the nine Yaeyama Islands, which are, in fact, closer to Taiwan than they are to the main island of Okinawa. The foremost island of the group is Ishigaki. The Yaeyama Islands have existed in such relative isolation for much of their history that they possess two distinct languages. Here we see a guardian lion (Shisa) on a red-tiled rooftop.

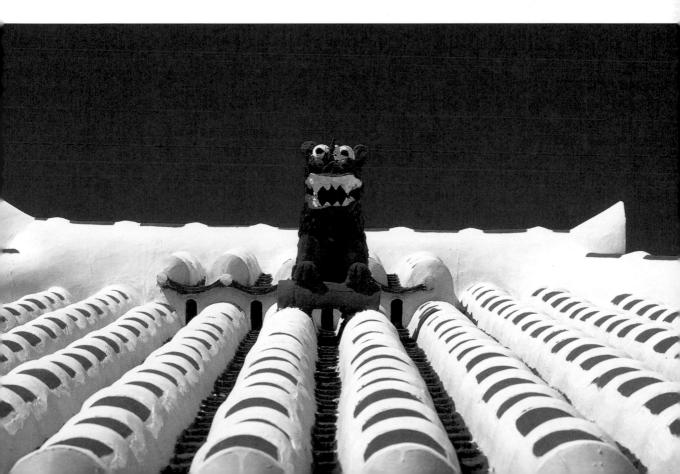

The History and Culture of JAPAN

Japan is an archipelago comprised of four large islands and over 6,000 lesser islands. It is about the size of, say, Italy or California. In terms of population it ranks seventh in the world, but the density of population per unit area under cultivation is the highest in the world. This is because Japan is two-thirds mountains, and alluvial plains occupy only some ten percent of the land. There are more than forty active volcanos and frequent earthquakes. Climate and weather vary greatly—from arctic to tropical—because of the length of this chain of islands. This length has also created a people whose origins may be traced, on one hand, to settlers from China and Korea and, on the other, to peoples from the south, such as Polynesia.

History

It is commonly said that Japan underwent three major cultural transformations. After its early periods (the Jomon, Yayoi, and Kofun periods), Japan entered its historical phase with the introduction of writing and the importation of Buddhism from the mainland in the sixth century. From 710 to 1185 permanent capitals were established at Nara and later at Heiankyo, now Kyoto. By the tenth century Chinese influence began to wane, and Japan developed a culture of its own. It was during this transformation that the Japan we now know emerged.

The official missions to China were terminated in 894, and in the year 1000 Lady Murasaki was writing *The Tale of Genji*, often called the world's first novel. During the middle ages which followed (1185-1573), Japan underwent a second transformation in the wars that all but tore the country apart. TheKamakura Shogunate was established, but peace was sporadic. Though many of Japan's architectural monuments were built during this era, just as many were destroyed. The Sengoku period (1467-1573) was a century of anarchy. A military peace was achieved when the last Ashikaga shogun was overcome, and the Tokugawa clan, under the warlord Ieyasu, emerged victorious. One of the results was a cultural shift from the old capital of Kyoto to the new political center of Edo (now Tokyo) and eventually the country was closed to outside influence, nominally allowing no foreigners in and no Japanese out.

The third cultural transformation occurred three hundred years later, caused by the collapse of the Tokugawa system and the appearance of the American Commodore Perry at the port of Edo. During this time the emperor was reinstated as a figure of authority, factions fought for power, and it was determined that drastic reforms were needed if foreign domination was to be avoided.

In a complete transformation, the Japanese adopted the Meiji Constitution (1889) and began the task of "catching up" with the West. It did this with eminent success. In only a few decades a Western way of life began to define Japan and, having ably resisted imperialism for much of its history, Japan now began to practice it. It won the Sino-Japanese War (1895) and gained Taiwan, won the Russo-Japanese War (1905) and, eventually, annexed Korea. So successful was the Japanese military that it took over the government itself, and by 1937 Japan was invading China. Finally, only seventy years after it had opened its gates to the West, Japan was engaged in one of the greatest "war efforts" in history — including the bombing of Pearl Harbor in 1941 and the declaration of war against the United States. Despite initial successes, however, Japan spectacularly lost the war. The Americans destroyed most of the country's cities and obliterated two of them, Hiroshima and Nagasaki, with atom bombs. There followed seven years of occupation by the Allied Forces, which included the United States and the United Kingdom. During this period yet another cultural transformation occurred, as Japan once again joined the family of nations.

Religion

The indigenous belief in Japan is Shinto. It has been practiced for two thousand years but has no doctrines and few texts. The *kami*, which can only be translated "deity," are numerous but remain designations rather than attributes. Their place of worship is the shrine, but there is nothing there indicating the transcendence seen in other religions.

Japan's other belief is Buddhism. Introduced from Asia in the sixth century, it has a "deity" in the Buddha himself, and transcendence is one of its teachings, with the place of worship being the temple. There are also newer religions with small congregations. Christianity makes up less than one percent of Japan's believers.

There is reason, however, for wondering just how important religion is in Japan. According to statistics there are over eighty-three million Shinto adherents and, at the same time, nearly eighty million followers of Buddhism. Since the population of the country is around one hundred twenty million, it becomes apparent that a majority practices a double religion. If, according to Western religious ideas, two antithetical religions can be practiced simultaneously, one may wonder how deep the belief.

But that is a question which would not occur to a conventional Japanese. Religion is primarily for use, and its duties are thus apportioned. A new-born child is presented at the Shinto shrine, and weddings are also often Shinto ceremonies. Death, however, belongs to Buddhism, which oversees most funerals.

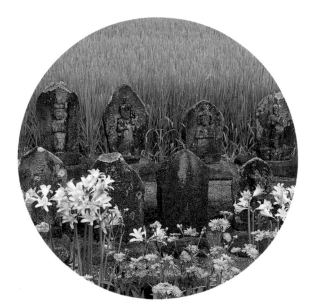

New Year's is celebrated at the Shinto shrine, pictured at top, so are weddings, above. Shinto's original folk beliefs are also celebrated in more rustic settings — these *dosojin* fertility statues (bottom) standing in the rice paddies, for example.

Those arts thought typically Japanese mostly reached their final form during and after the fifteenth century, often under the patronage of the various feudal lords of the period. All of them share an aesthetic economy, a quality which is still much admired.

The tea ceremony (below) consists, as one of the earliest masters said, of drinking tea, nothing else. However, this ceremony, the *chanoyu*, is simple only in the most sophisticated sense. Like most of the traditional arts, the

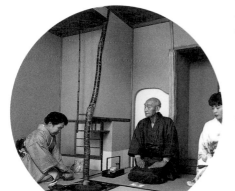

aim is the achieving of an inner accord — something necessary in the war-torn and anarchic fifteenth century.

Likewise, the rituals of calligraphy (*shodo*) and flower arranging (*ikebana*) aim at creating both a work of art and at the same time an inner sensibility. A degree of contemplation is necessary for both creation and appreciation, and its fostering was the aim of the art itself.

Though all of these arts are maintained by traditions that would seem to thwart simplicity, these traditions serve to control the art and to make an aesthetic continuity possible. For this reason, the traditional arts of Japan are like a school which educates through example and is headed by the latest in a line of instructors, the *iemoto*. It is from him (more rarely her) that the tradition descends: how water is boiled and tea whisked and served; how the brush is held and the strength of the line ensured; how branches are cut to ensure a perfect arrangement — all of these depend upon rules handed down from ages past.

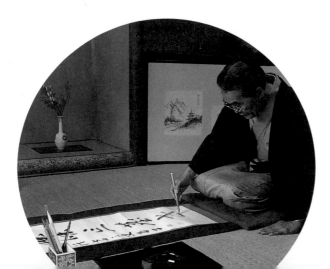

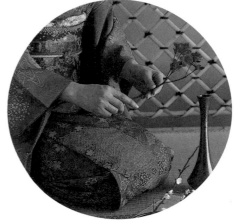

Martial Arts

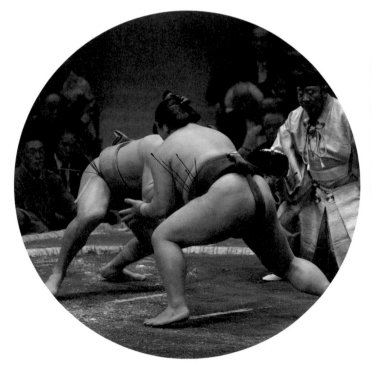

Collectively, the many martial arts of Japan are known as *budo*. This includes a number of sports as well. Among the most visible is sumo (below), a kind of ritualized wrestling which perhaps originally came from the Asian mainland. The *sumotori* throws his opponent or forces him out of the ring. This sounds more simple than it is. There are more than seventy different techniques and the performance is filled with rituals and Shinto-originated ceremonial details. More than thirty of the highest ranking professionals compete in six annual fifteen-day tournaments which are always televised and remain popular.

More widely known abroad are three later but still traditional Japanese martial arts: judo, aikido, and karate. Of these, judo (upper right) remains the most popular. A late modernization of an Edo-period fighting style taken from *jiu-jutsu*, it employs three phases of training. First, the *kata*, standard learning forms which are practiced daily and strenuously. Second, free-style exercise (*randori*), in which techniques are applied. And, finally, the matches themselves. Points are given for throwing an opponent, for pinning him, for subduing through armlocks, and so on.

Another popular *budo* sport is kendo. Originally this was "the way of the sword" and was a samurai accomplishment. After the Meiji reforms, however, an especially designed bamboo stave was used instead of a sword, and both breastplates and faceguards were employed. The aims remained the same, however — to hit three parts of the opponent's body (head, wrist, torso) or to finish him off with a lunge at the throat.

Arts and Crafts

In traditional Japan there was, as in traditional Europe, not much distinction made between what was a craft and what was an art. Art is crafted well, and craft is usually artful.

Such crafts as lacquering (left) require both skill and dedication. The finished pieces take many coats of lacquer, each of which must be thoroughly polished once it has dried. Likewise, Japanese ceramics require a dexterity and a competence not often found elsewhere. Coupled with a complete knowledge of materials is the overriding understanding of perfect functional design. It is perhaps this which distinguishes Japanese arts and crafts alike.

The superlative ability of Japanese wood-block print artists is based upon the same combination. Artists such as Hokusai (1760-1849, below) and Sharaku (active 1794-95, right) designed, drew, cut, and printed with a complete knowledge of their medium while, at the same time, projecting the vision of an artist. The exceptional perfection of Japanese carpentry, in the creation of domestic objects found in the house, and in the house itself, attest to this combination of regard for materials and respect for functional form.

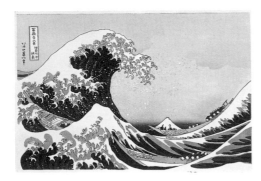

The Traditional Life

Though Japan is changing swiftly, its traditional culture is still centuries old, and the erosion of the new spares large swathes of the old. The inherited culture of the past is thus still very much a part of everyday Japanese life.

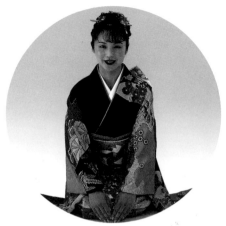

Kimono

Though not nearly as common as it was even a century ago, the kimono is still seen, particularly at ceremonial occasions such as weddings and funerals, and also at such celebratory times as school graduations, holidays, and cherry blossom viewing. It is a wrap-around garment with rectangular sleeves, made of vertical panels of cloth and bound with an *obi* sash. The difference between men's and women's garments is not so much in the structure as in the cloth used, the length of the sleeves, and the amount of decoration allowed. With kimono being less worn, the unit price of each has gone up, and so a proper formal kimono is extremely expensive, which, in turn, prevents people from purchasing them.

Rice

Despite the proliferation of the types of food now available, the main staple of the Japanese diet remains rice. In the postwar years, while Japan's economy was recovering, rice consumption increased, reaching a peak of almost 120 kilograms (265 lb) per person in 1961. Although the pattern has since decreased, rice remains a definite part of the national diet.

It is prepared in a number of ways. Though customarily boiled and eaten plain, it can also be pounded into a kind of dough called *mochi*, may be sliced into rice crackers (*sembei*), and used as the base in such confections as *mochigashi*.

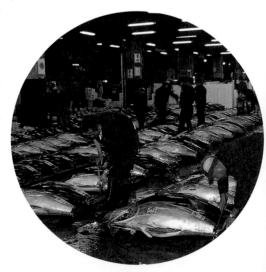

Of course, it can also be used as the base of Japan's most popular, and now most famous dish, sushi. Various ingredients are laid atop a portion of flavored boiled rice (*sushi-meshi*). The ingredient most popular is fish, usually raw. It is not surprising that Japan is the world's largest consumer of seafood — with a high of ten million tons a year — the work of some two hundred thousand local fisheries.

The daily fish markets (facing page, bottom right) are filled with sellers and buyers. Prices reach near astronomical heights as the larger fish (such as the popular *maguro* tuna) become more and more scarce. This scarcity has resulted in higher priced sashimi and sushi and also in often less traditional ingredients.

Still, old-fashioned sushi remains the most popular of Japanese dishes. It comes in several forms. There is the *hakozushi*, made by pressing rice into a wooden box, topping it with fish, and slicing it into bite-sized pieces. There is also *makizushi*, around which seaweed (*nori*) is rolled, and *chirashizushi*, which consists of seafood, vegetables, or other ingredients on top of sushi rice in a bowl. By far the most popular, however, is *nigirizushi*, which is sushi. shaped by hand (right). Here is the succulent tuna (*toro*), sea urchin, caviar, shrimp, shellfish.

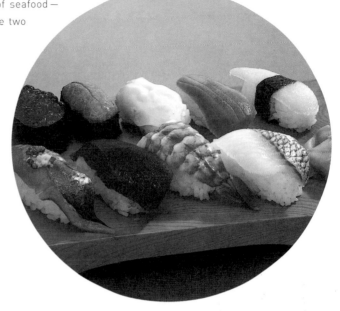

Sake

Most traditional cuisine is accompanied by a flask of warm sake (left). Though whiskey, beer, and wine have all made inroads, sake remains (along with the schnapps-like *shochu*) the national drink. Indeed, there are over 3,000 manufacturers of refined sake in Japan. Each of these local sakes have their own virtues, and a sake connoisseurship is as common among Japanese drinkers as is a knowledgeability of wine among Western drinkers.

Crude sake is about 40 proof, and store-bought sake is about 32 proof, making it about as alcoholic as sherry. Indeed, like sherry, sake is often associated with having a drink before a meal, an affiliation it has long had. It was first introduced around the third century BC. By the twelfth century it was being more widely consumed, and by the fourteenth it was being taxed — a sure sign that brewing sake was a profitable business.

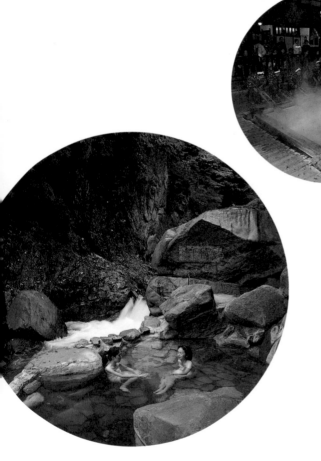

The Traditional Life

Onsen

Though sake continues to be drunk just about everywhere, a favorite location for doing so is still the hot spring (*onsen*). Here one may sit on the veranda or in the hot water itself, sipping sake, looking at the blossoming cherries or at the falling snow.

One of the joys of traditional Japan, one which is growing rather than diminishing, is enjoying the numerous hot spring spas. In this country, where volcanos are active and earthquakes are frequent, there is a total of 3,000 hot spring resorts, as compared with the 149 of Italy or the 124 of France.

Further, in Europe and the Americas, a trip to a hot springs is seen mainly as a way of improving one's health. This is true, to an extent, in Japan as well, but the main incentive of a trip to the *onsen* is not health but pleasure. To sit enveloped by healing waters amid the natural beauty of an outdoor bath (*rotenburo*, lower left) is to experience a pleasure rare in modern life.

Some Japanese *onsen* are nicely cool, others are very hot indeed. That of Kusatsu (upper right) is 48°C (118°F), which is so hot that the water is beaten and mixed with air so that it is bearable. The approved therapeutic method at Kusatsu is three-minutes full immersion four times a day.

In keeping with the natural environment of the Japanese *onsen*, bathing costumes are never worn. Only a small towel is permitted, and in some rural *onsen* the time-honored custom of mixed bathing is still observed. In all, the traditional Japanese hot-spring bath is one of the most enduring and enjoyable of the inherited pleasures.

Matsuri

Another traditional enjoyment is the *matsuri*. Usually the word means a folk festival, but it also refers to other ceremonial occasions which form a larger category of annual or seasonal observances. These two categories tend to overlap, but the former is Shinto-influenced and the later is Chinese and/or Buddhist oriented. In any event, both are much looked forward to and much enjoyed when they arrive. New Year festivities are, for example, always observed as a kind of domestic *matsuri*. In the traditional *tokonoma* alcove, in homes that still have one, objects symbolic of the season are placed. These may include (as at upper left, facing page) the paddle used in the New Year's game

of battledore and shuttlecock, piled up cakes of rice *mochi*, and a formalized ikebana arrangement using seasonal materials. In addition, the subject of the pictorial scroll chosen for New Year's is usually considered felicitous — such as a silk painting of the long-lived crane.

The food connected with the various domestic festivals is also special. The most elaborate is New Year's food, the expensive and time-consuming combination of flavors called *osechi-ryori*. Here (top, right) in their lacquered boxes are *kazunoko* herring roe, vinegared burdock and sweetened black beans. There are many other kinds of foods as well, including lobster, winter mandarin oranges, and a sweetened sake called *otoso*.

One of the most spectacular of the household ceremonies is the March 3rd Hina Matsuri, which observes Girls' Day and brings out the tiered platforms holding the *hina* dolls. A whole set represents emperor, empress, attendants, and musicians in ancient court dress (above). While admiring the dolls, the girls of the family celebrate by eating *hishimochi* (a diamond-shaped rice cake) and drinking *shirozake*, a mild beverage made with rice malt and sake.

The boys at one time had their own Boys' Day on May 5th, but this is now nationalized as Childrens' Day. Nonetheless, many of the customs from Boys' Day survive. One of them is the flying of carp-shaped kites from poles in the yard. Traditionally, there is one fish for each son. The carp is chosen because it is said to be so brave that it not only climbs waterfalls but also lies perfectly still under the fishmonger's knife.

The Traditional Life

Another Boys' Day attribute is the celebration of the iris season. These flowers are thought to symbolize budding boyhood and are often strewn in the bath on Boys' Day so that the sons of the household will grow up strong. In addition, just as the girls have their dolls, so do the boys — child samurai in full armor (right).

Japan has many seasonal and public festivals such as the Nebuta Matsuri in Aomori, the Awa Festival in Tokushima, and the Sanja Festival in Tokyo's Asakusa. Kyoto has the most famous of all summer festivals, the Gion Matsuri (bottom, left). Some thirty enormous *yamaboko* floats with tableaux and musicians are pushed and pulled along the streets of the old capital.

Sometimes the two kinds of *matsuri*, the public and the private, the social and the domestic, are merged as in the festival of Jugoya, an observance of the full moon of autumn. While there are moon-viewing parties to join, there are also decorations in the home. Typically these are arrangements of *susuki* grass, which is said to resemble the felicitous rice plant. Also displayed are the tiny skewered dumplings associated with a good harvest.

On the evening of the fifteenth night of the eighth month in the old calendar, viewing the moon is still considered a notable traditional pastime and a proper domestic *matsuri*. The orb itself is designated the *tsukimi*, which means a full harvest moon — and its accouterments are considered a part of the view (bottom, right).

Though modern Japan is much different from old Japan, there are still many reminders of a more traditional time. Eating and drinking patterns change slowly, and there is always need for a rite, a ritual, or a festival.

Kenzo Takada

Born in Hyogo Prefecture, world-famous fashion designer Kenzo Takada graduated from Bunka Fashion College in Tokyo in 1961, and in 1965 went to France, where he presented his first collection in 1970. He was named Chevalier de l'Ordre des Arts et Lettres in 1984. In 1999 he was decorated with the Order of the Purple Ribbon. That same year he exhibited his final Paris collection for the Kenzo brand and left to pursue other creative work. He designed the official Japanese uniform for the 2004 Athens Olympics. In 2005 he announced a new collection, "Gokan Kobo," in Paris.

JAPAN : a pictorial portrait

2005年11月9日　第1刷発行
2007年1月30日　第2刷発行

編　　者　　IBCパブリッシング株式会社
発行者　　賀川　洋
発行所　　IBCパブリッシング株式会社
　　　　　　〒107-0051 東京都港区元赤坂1丁目1番8号
　　　　　　赤坂コミュニティビル5F
　　　　　　www.ibcpub.co.jp
発売元　　日本洋書販売株式会社
　　　　　　TEL 03-5786-7420

デザイン　　斉藤　啓（ブッダプロダクションズ）
印刷所　　大日本印刷株式会社

© 2005 IBC Publishing, Inc.

ISBN 978-4-925080-93-4
Printed in Japan

GOOD LUCK !

At many Shinto shrines and Buddhist temples, you can have your fortune
told by drawing omikuji. The main types of fortune are good luck [吉] and bad luck [凶].